T0267918

IMAGES
*of America*

# NORTHAMPTON FIRES AND FIREFIGHTING

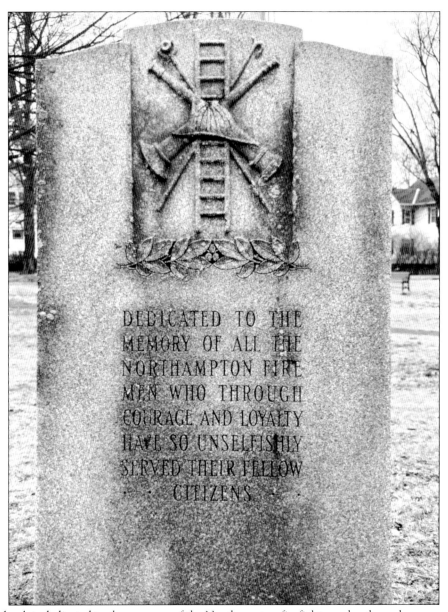

This book is dedicated to the memory of the Northampton firefighters who through courage and loyalty so selflessly served their fellow community members. This memorial at Trinity Row is 6 feet tall, 30 inches wide, and 10 inches thick. It was purchased by the Northampton Firemen's Relief Association, which helps members of the department who have been injured and families of members who have passed away in the line of duty. It was dedicated in 1954. (Author's collection.)

ON THE COVER: The Masonic Street Station was built in 1872 at a cost of $12,000 and was designed to house the wagons, horses, and even the police department lockup on the ground floor. In this 1924 photograph, Chief John Marlow is standing by his 1920 REO Speedwagon car along with the officers and firemen of the Northampton Fire Department. Marlow was the first paid fireman in Northampton, hired full time in 1894 and working his way up the ranks over 36 years. (Courtesy of the Northampton Fire Department Archives.)

IMAGES
*of America*

# NORTHAMPTON FIRES AND FIREFIGHTING

Joshua Shanley

ARCADIA
PUBLISHING

Copyright © 2023 by Joshua Shanley
ISBN 978-1-4671-6007-0

Published by Arcadia Publishing
Charleston, South Carolina

Printed in the United States of America

Library of Congress Control Number: 2023932954

For all general information, please contact Arcadia Publishing:
Telephone 843-853-2070
Fax 843-853-0044
E-mail sales@arcadiapublishing.com
For customer service and orders:
Toll-Free 1-888-313-2665

Visit us on the Internet at www.arcadiapublishing.com

# CONTENTS

Acknowledgments                                          6

Introduction                                             7

1.   Apparatus                                           9

2.   Fire Chiefs, Officers, and Firefighters            65

3.   Fire Stations                                       89

4.   Historic Fires                                      97

5.   Fire Alarm and Water Supply                        113

# ACKNOWLEDGMENTS

Thank you to Chief Jon Davine, Assistant Chief Andy Pelis, firefighter Dennis Nazzaro, and firefighter Daryl Springman of Northampton Fire Rescue. Also, I owe Dr. Elizabeth Sharpe, Laurie Sanders, and Marie Panik at Historic Northampton and Dylan Gaffney at the Forbes Library a great deal of appreciation for their help in providing context in telling the history of Northampton through the eyes of the fire department. Some of the details contained herein were captured through articles published in the *Daily Hampshire Gazette*, *Springfield Republican*, and *Holyoke Transcript-Telegram*. I am thankful to the publishers, reporters, and photographers who covered these matters over many years. Thank you also to Harry Jessup for research assistance. Finally, I am always in gratitude for the endless support and encouragement of my wife, Kristen, who was born and raised in Northampton and made it possible for me to become a townie in her hometown.

For more information and a detailed list of references and citations, please go to www.NFDHistory.org.

# INTRODUCTION

The area now known as Northampton was called Norwottuck or Nonotuck, meaning "the mist of the river," by Native Americans. In 1653, the land making up the bulk of modern Northampton was purchased from the native inhabitants. Colonial Northampton was founded in 1654 by settlers from Springfield, Massachusetts, and the town of Northampton was given its charter. The first buildings in town were made with wooden chimneys and thatch roofs. By 1659, early industry had been started, primarily with gristmills established along the Mill River, which ran through the center of the town at that time. The area had a population of about 500.

During King Phillip's War (1675–1676), Northampton, like many other recently settled New England towns, became a battleground. In October 1675, attacks using fire burned five houses and barns in the Meadows, near the Oxbow, and more in the area around Old South Street and Dewey Court. Later, on October 5, 1675, much of Springfield was burned to the ground—45 of the 60 homes were lost, along with most of the mills and other buildings—and as a result of escalating tensions in the region, a palisade was erected to protect the center of Northampton. Unfortunately, it was breached on the morning of March 14, 1676. More than a dozen people were killed and more injured during the short but intense battle. Nine houses outside of the wall and one inside the wall were burned. At that time, firefighting efforts were limited to bucket brigades.

It was generally recognized that building practices in Northampton when it was first settled, including wood chimneys, oversized fireplaces, and thatch roofs, were in large part responsible for house fires being all too common in the area as well as in other New England towns. There was no municipal water supply to provide ways for filling buckets and hand pumps, which, along with fire hooks and ladders, were the only means of extinguishing a fire. Instead, until one was built, the town relied on private wells and cisterns to provide water for firefighting. A fire at a malt house in March 1792 led to votes to raise money to buy fire protection equipment, but not before four stores on Main Street burned in October of that year.

The first fire apparatus in Northampton was purchased in 1793 for £60. It was a hand-drawn hand tub pump pulled by men. In the early days, pumps were transported by wagons that required teams of men to operate them. Some would pull from the front of the wagon, while others pushed from the sides, using large bars to engage the brakes. The pumps were then manually operated to make pressure that would draw water from tubs into leather hoses. In Northampton in 1827, before a formal fire department had been organized, the earliest hand tubs, the Damper and the Whale, were manned by volunteers who brought them to fires when needed.

Beginning shortly after the first fire engine was purchased, efforts were underway to build an aqueduct, which was made from hollowed-out logs. In 1804, another aqueduct company piped water from a spring near Round Hill to King Street and Pleasant Street. Another reservoir was constructed to supply the neighborhood off Elm Street, and this system remained in place until a larger gravity-fed reservoir was built in 1871. Several early cisterns were buried below

the streets in town and even underneath the Masonic Street Station, below the tower. Initially, these cisterns were used to fill hand tubs.

By the 1840s, Northampton's industries included paper, textiles, tools, and cutlery, but locals eventually specialized in silk, buttons, brushes, and even coffins. A spate of arson fires plagued the city during this period, continuing into the 1860s. In 1853, the Northampton Fire Department took delivery of the first mechanical steam-powered fire wagons, which were very heavy and could not be pulled by men. Horses were integral to the early department. Each station maintained horses that lived in dedicated stalls in the firehouses. The horses that pulled the fire wagons were equipped with harnesses that were suspended from the ceiling. When the horses were positioned underneath, a fireman would lower the gear and fasten the collars onto the horses. The horses would then be prepared to pull the heavy wagon from the station to the fire. Ansel Wright was the first chief engineer of the Northampton Fire Department, appointed in 1855. This spurred the official organization of a fire department in 1857, as recognized by the town bylaws.

Before formal firehouses were built, fire apparatus was kept in a variety of locations around downtown and Florence. These were first stored in the basement of Uncle John's Tavern, now the Hotel Northampton. The Deluge fire truck was manned by farmers and laborers and, along with older hand tubs, was kept in the basement of the First Congregational Church, built in 1812 and destroyed by fire in 1876. The Torrent fire truck was kept in the basement of the old town hall behind the county courthouse and staffed by local merchants and clerks. The staffing of these apparatus by different local workers led to a rivalry that was demonstrated in musters in the town center. Four fire wards were established in the late 1860s.

The Bay State Fire Station building was owned by Northampton Cutlery and loaned to the city. It was opened in 1864 and destroyed by fire in 1870. It was rebuilt and remained in service until 1950. The Masonic Street Station was built in 1872 at a cost of $12,000 and was designed to house the wagons, horses, and even the police department jail on the ground floor. In 1870, at a Florence town meeting, residents voted to purchase three new self-acting fire extinguishers. The first company was called Nonotuck Hose Company No. 1. It met in a small building in the rear of the First Congregational Church. Soon after, a second company was formed—Florence Hose Company No. 2—on Chestnut Street in a building owned by the Florence Sewing Machine Company. The Florence Fire Station on Maple Street was constructed in 1883 for $4,000 and replaced in 1972 with a new building at a cost of $400,000. The Leeds Fire Station was opened in 1900 and remained in service until it closed in 1973.

As of 1870, the Northampton Fire Department consisted of four separate companies—downtown on Masonic Street, Florence, Bay State, and Leeds. Each had its own set of equipment. A series of large fires in 1870 led to a push for a water supply system for the town. In 1884, the population of Northampton had grown to more than 13,000. Factories and mill buildings had some level of fire protection, including automatic sprinklers and watchmen responsible for patrolling the buildings on nights and weekends. The 1911 Pope-Hartford was the first piece of motorized apparatus for the Northampton Fire Department. It was purchased under Mayor Calvin Coolidge and marked a transition to a new age. Going forward, all apparatus was motorized. In 1916, the last horses used in the Northampton Fire Department were sold to a farm in Plainfield. In 1927, state building inspectors declared the Masonic Street Station unsafe. Repairs were made over the years, and the downtown headquarters remained in service until 1999, when the new Northampton Fire Department headquarters opened on Carlon Drive. It was designed for fire apparatus and ambulances.

Around 2015, the City of Northampton changed the name of its fire department to Northampton Fire Rescue to better represent its evolving mission, which included an increased focus on providing emergency medical services. In 2022, Northampton Fire Rescue responded to more than 8,000 calls to provide a variety of emergency services to the people of Northampton and surrounding communities.

# One

# APPARATUS

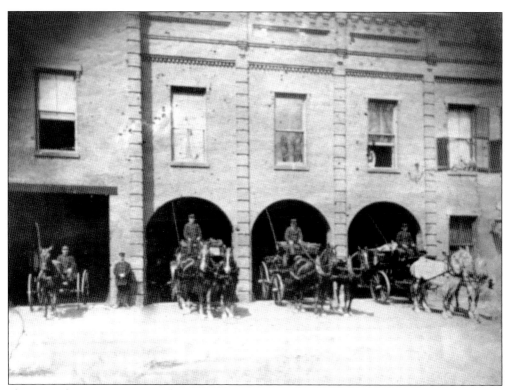

Shown on the apron in front of the Masonic Street firehouse are firefighters around the early 1900s, with four open bays framing the horse-drawn fire apparatus. In 1892, the station was headquarters for two steamers, one hand reel, two hook and ladders, two hand engines, seven two-wheel horse carts, one four-wheel hose wagon, five horses, and 8,400 feet of hose. The one-horse buggy in the far left bay was for the fire chief. The old Silsby steamer was in the rear of the apparatus bay. Additional horses would be brought over from a moving company on Gothic Street if needed. (Courtesy of Historic Northampton.)

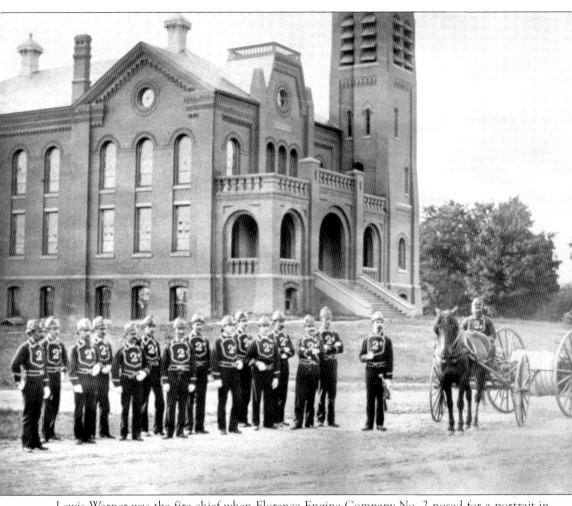

Lewis Warner was the fire chief when Florence Engine Company No. 2 posed for a portrait in front of Cosmian Hall in September 1880. This was before the original Florence Station was built on Maple Street in 1883, so this company first operated out of a small building on Chestnut Street owned by the Florence Sewing Machine Company. (Courtesy of Forbes Library.)

This map from 1895 of downtown Northampton shows the close proximity of the Masonic Street Station ("Engine House" on this map) and the button factory two doors down, which was owned by Chief Lewis Warner. The Northampton Firemen's Relief Association, of which Warner had been the first president, operated out of that building for years. Warner owned many properties in Northampton over the years. (Courtesy Historic Northampton.)

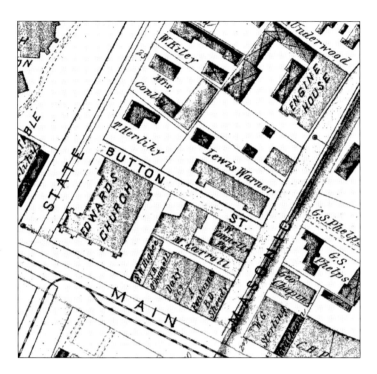

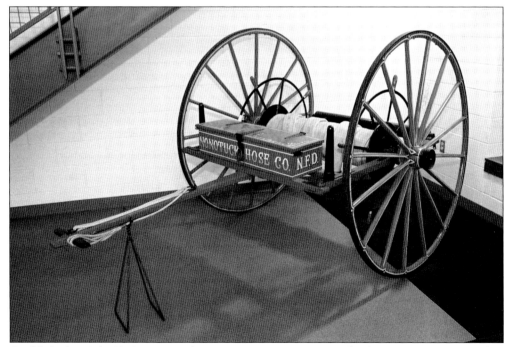

Established in July 1870, Nonotuck Hose Company No. 1 was the first company stationed in Florence, and operated out of a small wooden structure behind the First Congregational Church on Pine Street. The church was destroyed by fire on February 13, 1885. The restored 1872 hose cart of the Nonotuck Hose Company is on display at Northampton Fire Rescue headquarters. (Courtesy of Northampton Fire Department Archives.)

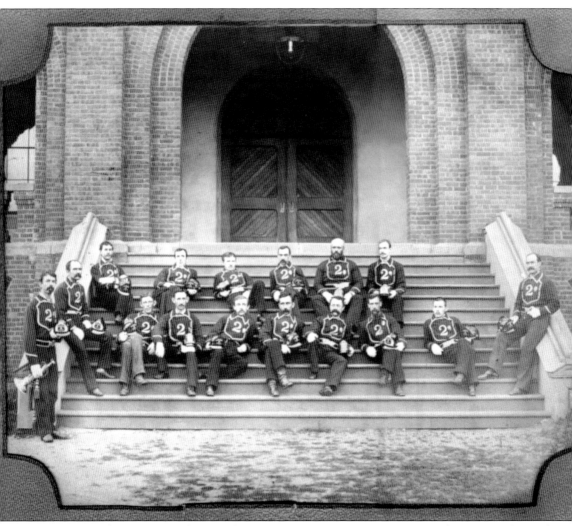

In September 1880, members of Florence Hose Company No. 2 pose on the steps in front of Cosmian Hall in their dress uniforms. In the early days, firemen pulled 1,300-pound hose wagons by hand, sometimes through mud and snow to the scene of a fire, leaving them exhausted before even beginning to put the fire out. (Courtesy of Historic Northampton.)

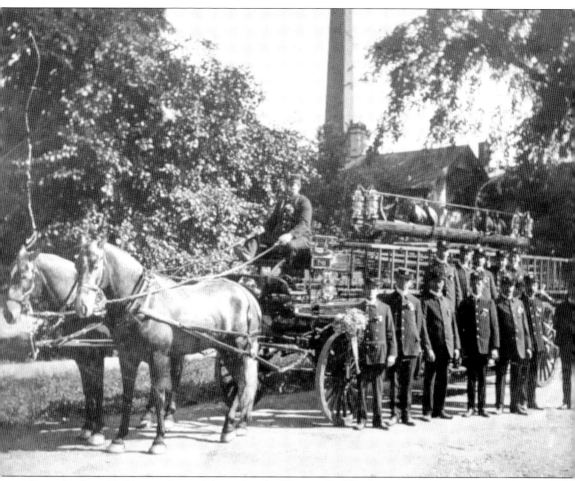

A new hook and ladder truck was delivered to the Florence Ladder Company in August 1902. The apparatus was manufactured by the Seagrove Company of Columbus, Ohio. In addition to the 14-foot and 65-foot ladders, each mounted on its own set of rollers for faster deployment, there were also other tools such as axes, pitchforks, shovels, wire cutters, fire extinguishers, and blankets. Six glass lanterns lit the truck. Altogether, there was a total of 308 feet of ladders on the 4,600-pound truck, which was pulled by two horses. (Courtesy of Historic Northampton.)

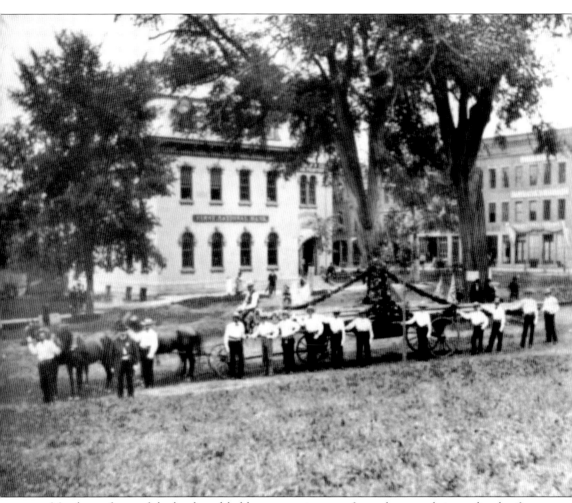

Members of one of the hook and ladder companies pose for a photograph immediately after a muster in the fall of 1879. First National Bank can be seen in the background, along with the Smith Charities brownstone behind the elm trees. Policeman Frederic G. Richards is on the left, in full uniform. The driver is Isaac N. Taylor. Next to Richards, from left to right, are foreman of the company Calvin B. Kingsley, Jonathan Strong, Orange Wright, Charles C. Kellogg, Spencer Cook, Luke Day, Charles C. Clapp, John Landry, Samuel C. Rose, and Samuel B. Strong. Benjamin A. Phelps and George D. Driscoll are seated on the rear deck of the wagon. William F. Knapp was a member of this company for more than 50 years before retiring in 1884, making him the longest-serving fireman in the United States at the time. (Courtesy of Forbes Library.)

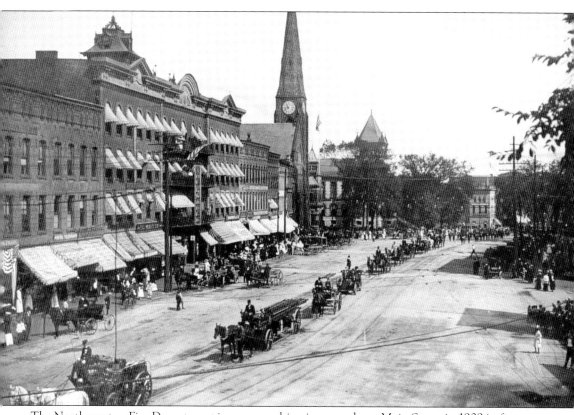

The Northampton Fire Department is seen marching in a parade on Main Street in 1909 in front of the Draper Hotel, marking the first observation of Firemen's Memorial Day. The Florence hook and ladder truck is following behind the hose wagon. (Courtesy of Forbes Library.)

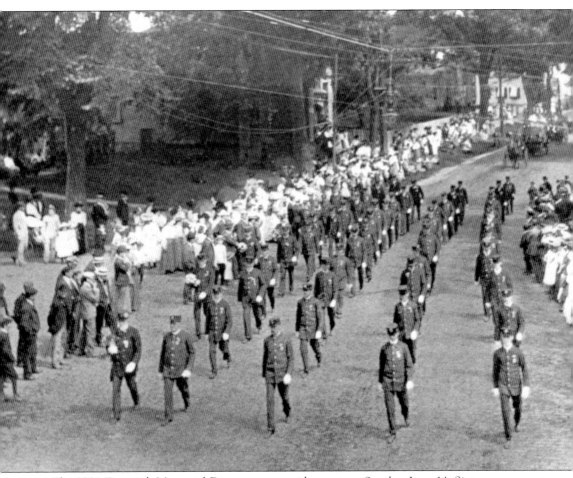

The 1909 Firemen's Memorial Day was a statewide event on Sunday, June 14. Sixteen graves—at Bridge Street Cemetery downtown, Park Street and Spring Grove Cemeteries in Florence, St. Mary's Cemetery, and Haydenville Cemetery in town—were decorated with wreathes. The entire department marched from the Masonic Street Station to St. John's Episcopal Church for a service dedicated to the firemen that evening. (Courtesy of Forbes Library.)

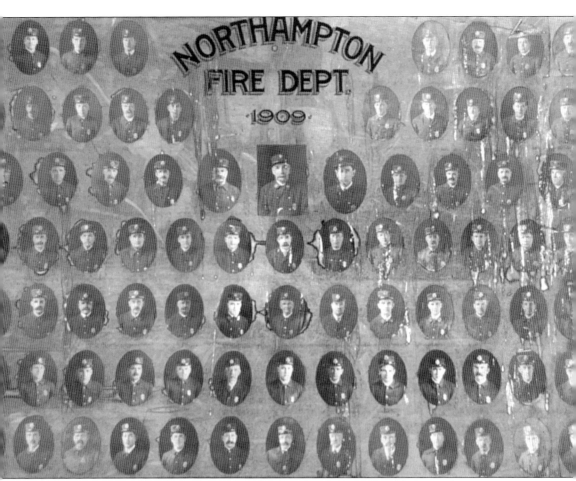

Eighty-one members of the Northampton Fire Department are seen in these formal portraits from 1909. Chief F.E. Chase is prominently located in the center. Officers can be identified by their double-breasted jackets. (Courtesy of Northampton Fire Department Archives.)

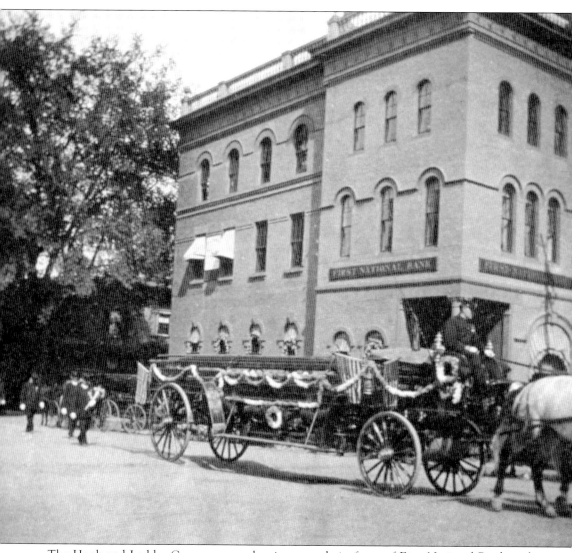

The Hook and Ladder Company marches in a parade in front of First National Bank at the intersection of King Street and Main Street before it was destroyed by fire in 1895. The Hook and Ladder Company was established in 1837, then reorganized in 1847 with Isaac Damon as foreman. It had 20–25 members. (Courtesy of Historic Northampton.)

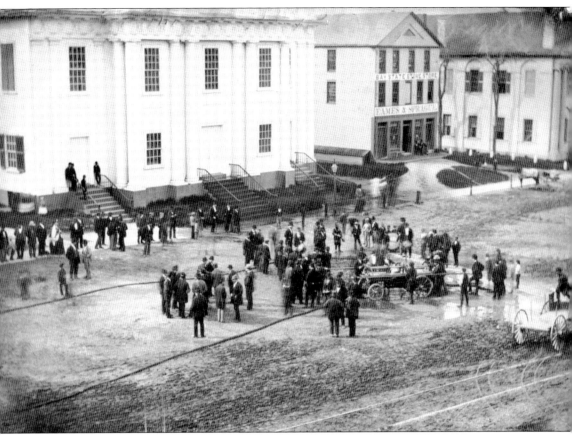

Torrent Engine Company No. 1, Deluge Engine Company No. 2, Washington Engine Company No. 3, the Sack and Bucket Company, and the Hook and Ladder Company were all put into service in 1853. Here, Deluge Engine Company No. 2 is staged for field day on May 10, 1876, in front of the "Old Church," designed by Isaac Damon in 1812, about one month before a massive fire destroyed the structure. (Courtesy of Historic Northampton.)

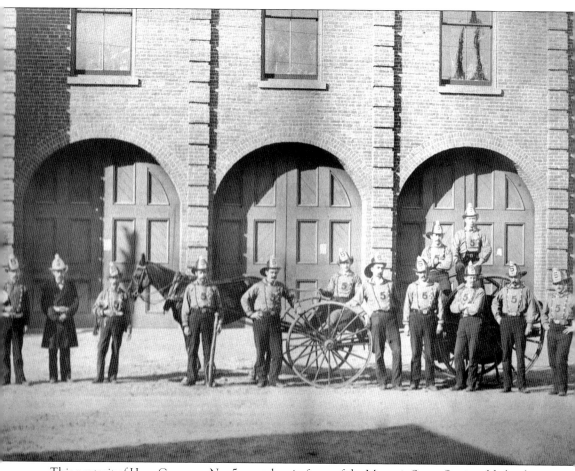

This portrait of Hose Company No. 5 was taken in front of the Masonic Street Station, likely when the company went into service in 1893. This hose wagon was one of two purchased from Rumsey & Co.'s works in Schenectady Falls, New York, for $415 each. These wagons were set up to lay hose in the bed rather than on reels. The other new hose wagon went into service in Florence. (Courtesy of Northampton Fire Department Archives.)

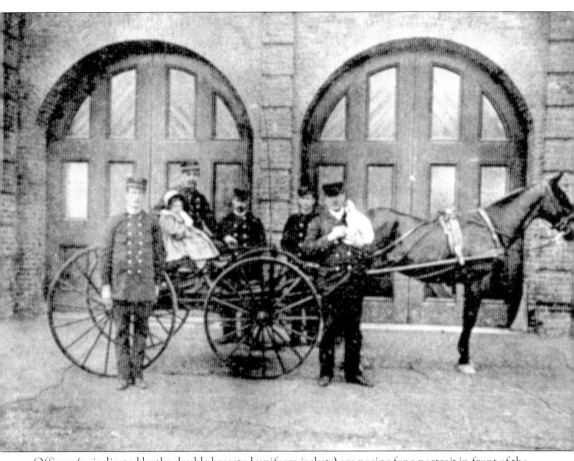

Officers (as indicated by the double-breasted uniform jackets) are posing for a portrait in front of the Masonic Street Station during the inspection and field day program in 1899. The fire department was reorganized that year under Chief Frederick E. Chase. Call firefighters were paid $50 per year, and three new permanent men were added to the force with an annual salary of $600. There was an average of 60 calls per year at that time. (Courtesy of Forbes Library.)

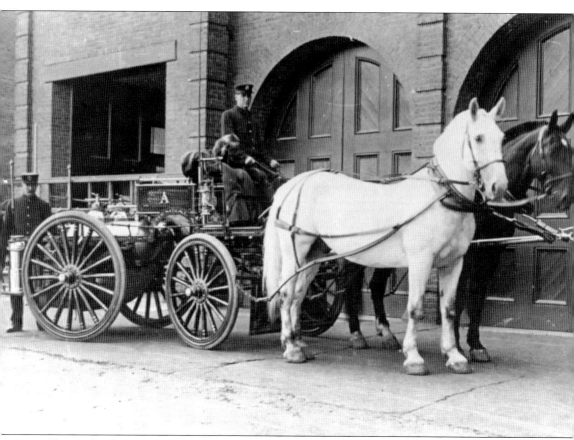

Chemical Engine A is in front of the Masonic Street Station. The 35-gallon copper tank was nearly filled to the top with water and bicarbonate of soda and secured with a threaded cap. Within the tank, there was a quart-sized lead container that was filled with sulfuric acid. Once at the scene of a fire, a lever would dump the acid into the soda, and it would be agitated by paddles to build about 300 pounds of pressure. A one-inch line would deliver the chemical solution to extinguish the fire. (Courtesy of Northampton Fire Department Archives.)

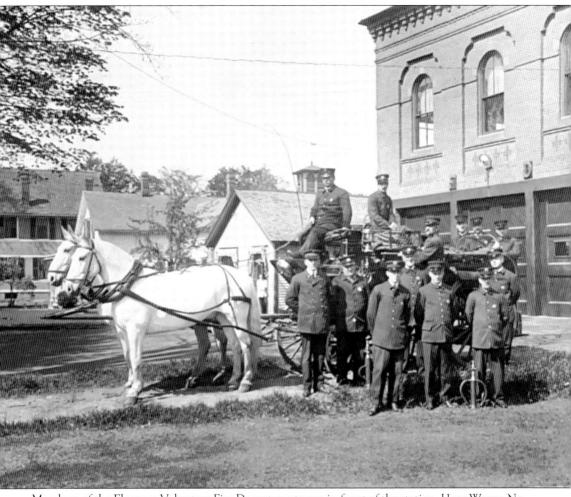

Members of the Florence Volunteer Fire Department pose in front of the station. Hose Wagon No. 4 operated out of the Florence Fire Station, one of five four-wheel wagons in service by 1899, each pulled by two fire department horses. More horses could be brought from Howes Brothers across the street if needed. The following names are noted on the back of the original print: Bill Purcell, Herbert Giles, Mr. Davenport, Pat Halpin, Sven Gustafson, Frank Boynton, George Hayes, Sam Hawksley, Bill Bray, John Black, Jim Torpey, Charlie Andrews, and Jim Morrisey. Davenport was Roy W. Davenport, who was involved in a three-year public political battle after charges by alderman Robert Emrick in 1935 that Captain Davenport was not in quarters when a fire alarm came in. Davenport was ultimately demoted to the rank of private. (Courtesy of Historic Northampton.)

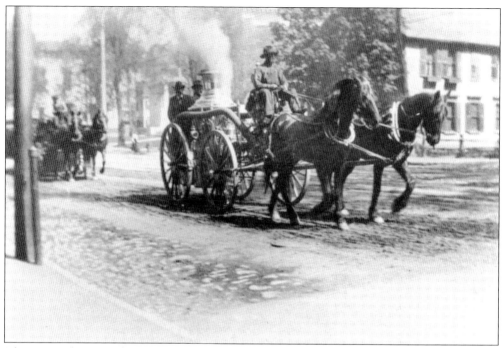

John Tappan (1781–1871), a native of Northampton, gifted the town $500 for the purchase of a steam engine, which was named after him. Tappan's second wife was the daughter of Asahel Pomeroy, who along with several others was instrumental in early water supply efforts in Northampton. Above, the Clapp and Jones steam engine—John Tappan No. 1—races toward a fire alarm on Main Street in 1914. (Courtesy of Historic Northampton.)

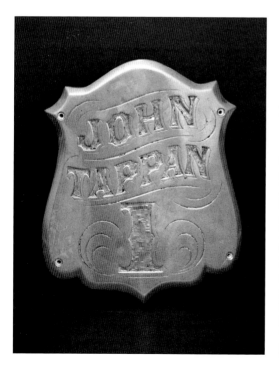

John Tappan moved to Boston in 1799 to work in the importing business. In 1805, while returning from a trip to England, his ship struck an iceberg and sank. Twenty-seven passengers and crew drowned, but Tappan was able to get to a lifeboat, and after three days was rescued by a passing ship and returned to Boston a changed man, more religious and sober. In addition to his generous contribution to the Northampton Fire Department, he was also a member of many charitable organizations across Massachusetts for much of his adult life. He passed away in Boston in March 1871 at the age of 80. This is the brass plate from the John Tappan No. 1 steamer. (Courtesy of Northampton Fire Department Archives.)

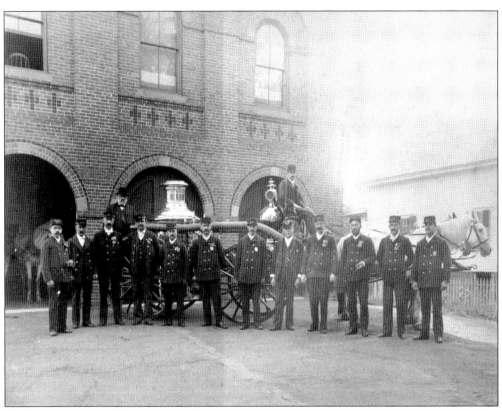

On October 13, 1871, a new steam fire engine—the John Tappan No. 1—and 2,000 feet of hose from the Clapp and Jones manufacturing company of Hudson, New York, was delivered. The apparatus cost $4,100. The town had only recently taken action to bring water through the streets to hydrants for the purpose of fire protection. Additionally, 1,000 feet of leather hose was purchased from Josiah Gates and Sons of Lowell. (Courtesy of Forbes Library.)

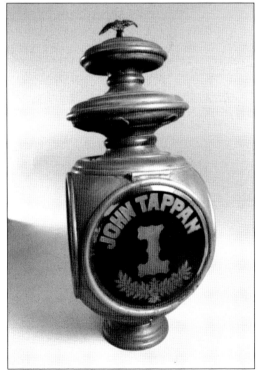

This bronze and glass lamp sat atop the Clapp and Jones steamer John Tappan No. 1. The glass is blue and red on two sides, with an engraving of a fire engine on the third side, and clear glass embossed with a hand-etched design on the fourth. A brass bird sits on top of the lamp. The bottom has threads for attaching the lamp to the fire truck. (Courtesy of Historic Northampton.)

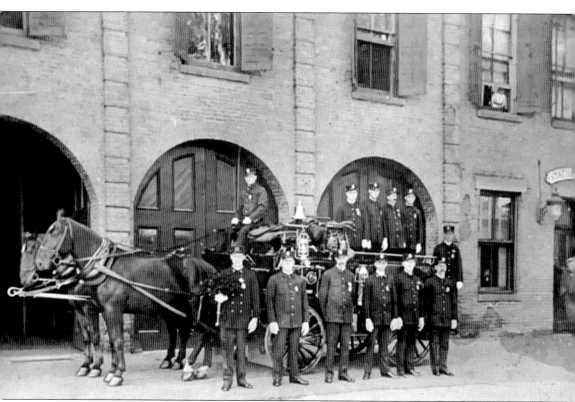

When it was first opened in 1872, the Masonic Street Station also housed the police department lockup on the right side. The Northampton Police Department was established in 1884 with a small office on the first floor of city hall. Beginning in 1782, there was a Society for the Detention of Thieves and Robbers staffed by volunteer constables that used a jail on Michaelman Avenue. This photograph was taken in the 1890s. (Courtesy of Historic Northampton.)

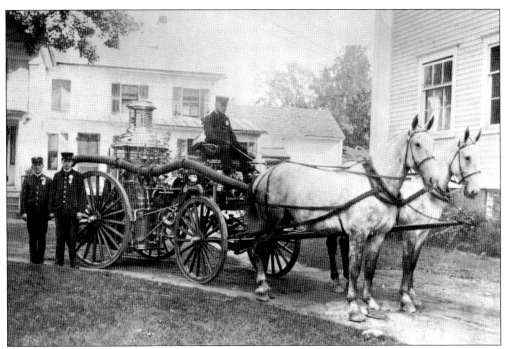

In April 1889, this Silsby steam engine, indicated by a "2" on the stack and "NFD No. 2" under the bench, was put into service at the Masonic Street Station, and the John Tappan No. 1 steamer was moved to Florence. The Silsby was a third-class steamer, serial No. 935, manufactured in Seneca Falls, New York. It was tested when delivered, and "steam was raised and water sent through the hose in six minutes and 44 seconds," according to the *Boston Globe*. It was described as a "handsome machine but develops a roaring sound that is very unpleasant." (Courtesy of Historic Northampton.)

In 1872, the John Tappan Steamer Company had a force of 30 men, led by foreman E.V. Foster. In this photograph, the Tappan Engine No. 1 company marches in a parade in front of the First National Bank at the intersection of King and Main Streets around 1890. (Courtesy of Historic Northampton.)

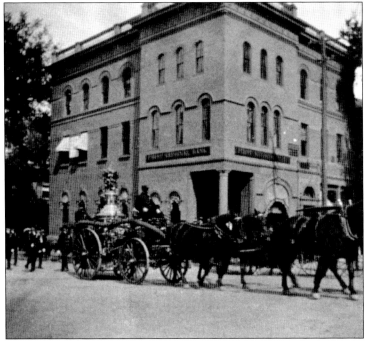

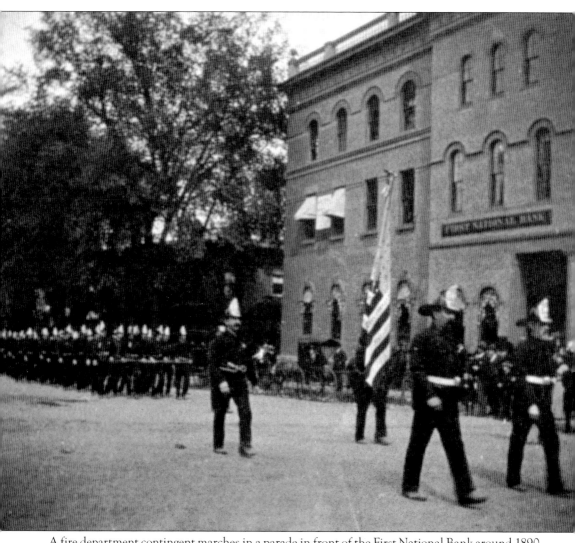

A fire department contingent marches in a parade in front of the First National Bank around 1890. The bank was destroyed by fire in 1895 and rebuilt in 1928 in the Art Deco style. The building was later home to the jewelry store Silverscape for 44 years. (Courtesy of Historic Northampton.)

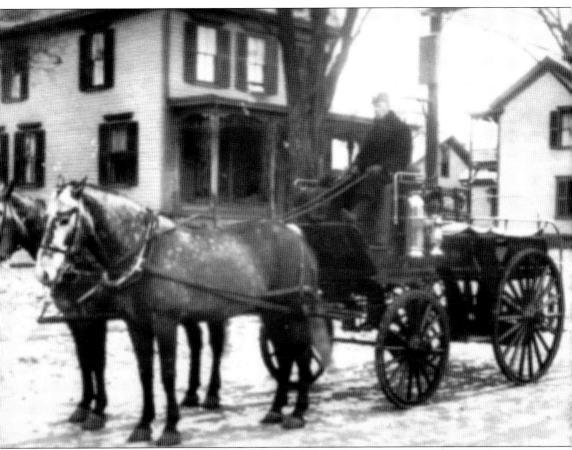

Chemical A was purchased in 1898 and was staffed by three permanent men and eight call men under the leadership of Capt. J.T. Lucier and Lt. W.A. Preece. The newly organized company responded to its first alarm—Box 38—on June 3, 1899. The sulfuric acid in the 2.5-gallon soda-and-acid extinguisher mounted on the sideboards could burn through firemen's uniforms if it came into contact with them while putting out a fire. (Courtesy of Forbes Library.)

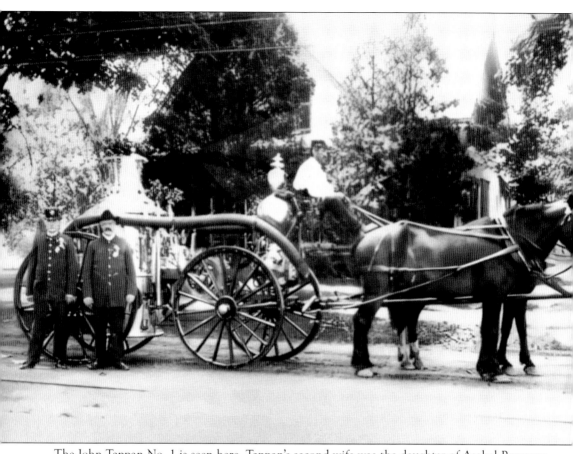

The John Tappan No. 1 is seen here. Tappan's second wife was the daughter of Asahel Pomeroy, owner of the Pomeroy Tavern, where a fire was reported to have broken out on October 12, 1792, quickly spreading to three other buildings. (Courtesy of Historic Northampton.)

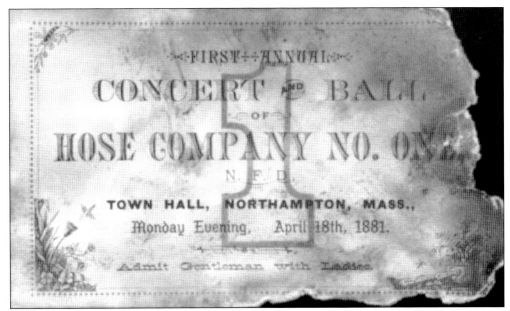

This ticket was for the first annual concert and ball of Hose Company No. 1 on April 18, 1881. Hose Company No. 1 was disbanded in 1882 but quickly reorganized by Chief Warner, who made William Bailey the foreman. (Courtesy of Historic Northampton.)

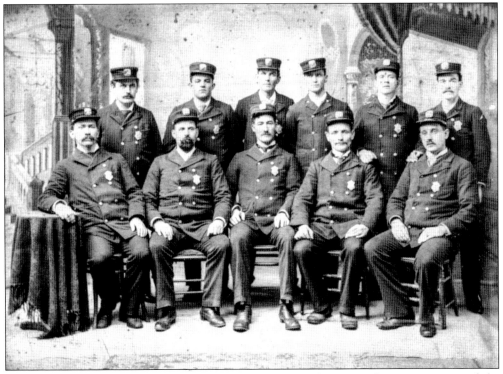

In this early photograph, Northampton Fire Department officers pose for a portrait around the 1880s. (Courtesy of Historic Northampton.)

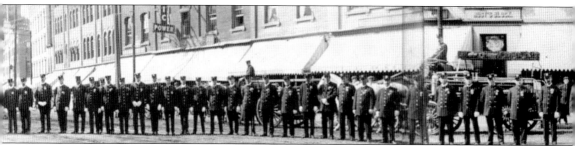

This panoramic photograph of the entire Northampton Fire Department was taken in June 1909 on Main Street in front of Crackerbarrel Lane. Firemen had gathered in dress uniform on the

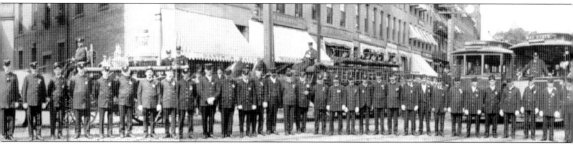

occasion of the first statewide Firemen's Memorial Day. (Courtesy of Forbes Library.)

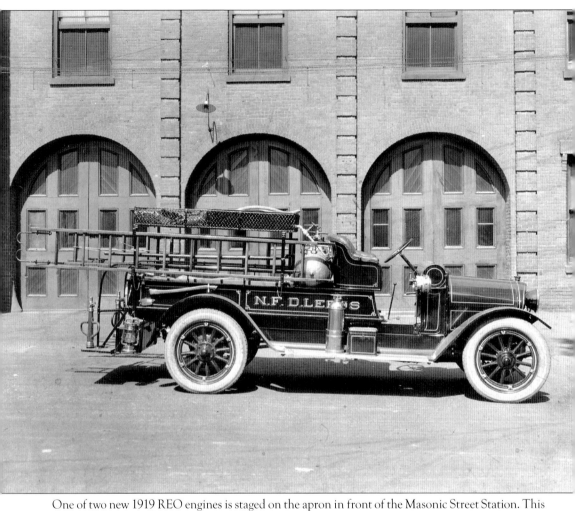

One of two new 1919 REO engines is staged on the apron in front of the Masonic Street Station. This one went to the Leeds Station. The other went to the Bay State Station. (Courtesy of Northampton Fire Department Archives.)

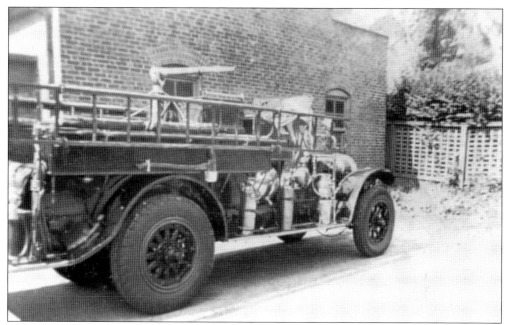

The Leeds 1919 REO engine was later reconfigured with a deck gun. The matching apparatus was set up as a brush truck, which was essential for responding to large grass fires. On July 22, 1905, four cottages at Laurel Park were destroyed by a grass fire, and many others would likely have been as well when the wind shifted suddenly if not for the efforts of Chief Chase and the Northampton Fire Department. (Courtesy of Northampton Fire Department Archives.)

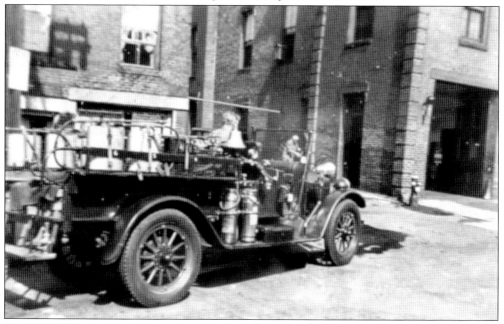

The 1919 REO engine reconfigured as a brush truck was involved in an accident responding to a fire while turning off Elm Street onto Massasoit Street. A young fireman, Charles Martin, who would later go on to be chief of the department, sustained serious injuries. (Courtesy of Northampton Fire Department Archives.)

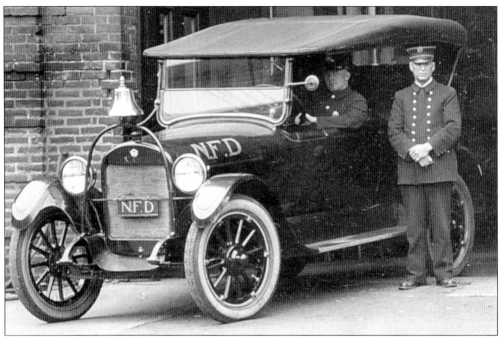

John Marlow became the first permanent fireman in the Northampton Fire Department on April 21, 1894. Rising through the ranks, he was appointed chief in 1920. He served for 36 years, the last eight as chief. He was 58 years old when he passed at Cooley Dickinson Hospital in 1928. The Masonic Street Station and Florence Station were both draped with mourning bunting, and flags were lowered to half-staff. First Assistant Chief Philip H. Sheridan was made acting chief until John Lucier was promoted to lead the department shortly after. In this 1924 photograph taken on Masonic Street, Chief Marlow is standing by his 1920 REO Speedwagon. (Courtesy of Forbes Library.)

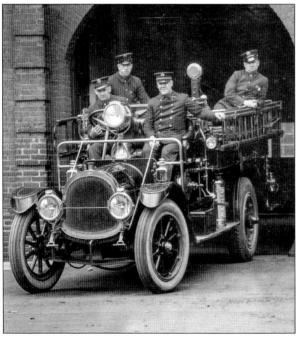

From left to right, firefighters Pat Ryan, Charles Dalton, John Lucier, and Havelock Purseglove pose in 1924 in front of the Masonic Street Station with the 1911 Pope-Hartford, the first motorized apparatus in the Northampton Fire Department. Lucier would later serve as chief engineer of the department from 1928 until 1939. The truck had a four-cylinder engine; was manufactured in Hartford, Connecticut; and cost between $5,000 and $5,700. Equipped with a 35-gallon chemical tank, 200 feet of one-inch chemical hose, a nozzle with Babcock threads, two 2.5-gallon extinguishers, a 24-foot extension ladder, and a 12-foot roof ladder, the Pope-Hartford operated out of the Masonic Street Station. (Courtesy of Forbes Library.)

The 1916 Jeffries quad hose truck had both four-wheel drive and four-wheel steering. It was later fitted with a trailer hitch and used to tow the older horse-drawn coal-fired piston pump steamers before being given to the highway department. Here, the Jeffries Quad is seen on the apron at the Masonic Street Station in 1924. (Courtesy of Forbes Library.)

Timothy Sheehan (left) and Capt. John Halpin (right) pose in the 1916 Pierce-Arrow ladder truck on the apron at the Masonic Street Station. The Pierce-Arrow was later transferred to the Florence Fire Station and remained in service until 1935. Captain Halpin began his service with the Northampton Fire Department in 1892 as a call man appointed by Mayor John L. Mather. He would later be appointed as a permanent fireman in 1900 and promoted to captain in 1916 by Mayor William H. Feiker. Halpin served more than 37 years. (Courtesy of Forbes Library.)

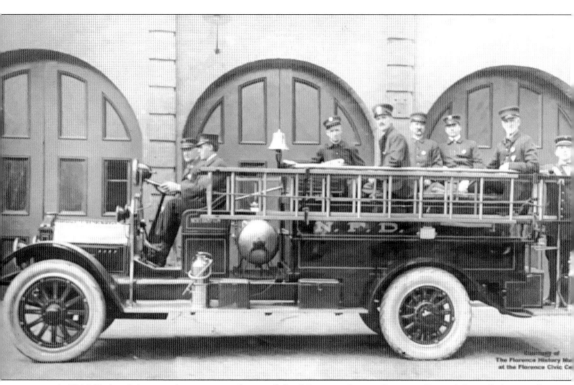

A 1916 Federal fire truck is seen in front of the Masonic Street Station. Seated from left to right are Chief Chase, Ed Cheezer, Herbert Giles, Len Parsons, William Purcell, John Black, and Capt. George Hayes. The man standing at right is unidentified. (Courtesy of Florence Historical Society.)

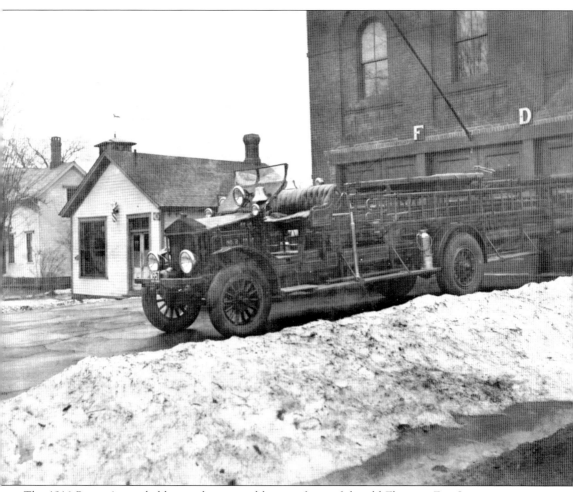

The 1916 Pierce-Arrow ladder truck, pictured here in front of the old Florence Fire Station, was deemed unfit for service in 1935 by insurance underwriters. It was replaced the following year by a 1936 Buffalo truck. (Courtesy of Northampton Fire Department Archives.)

Pictured is the 1916 Federal with snow chains at the Florence Fire Station, where it was relocated after the 1927 Seagrave apparatus was put into service at the Masonic Street Station. A Silsby steamer

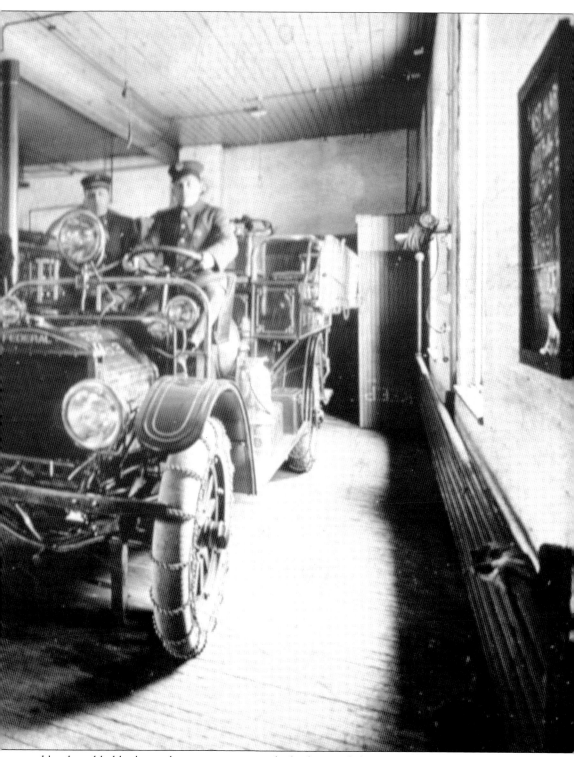

and hook and ladder horse-drawn wagon are in the background. (Courtesy of Northampton Fire Department Archives.)

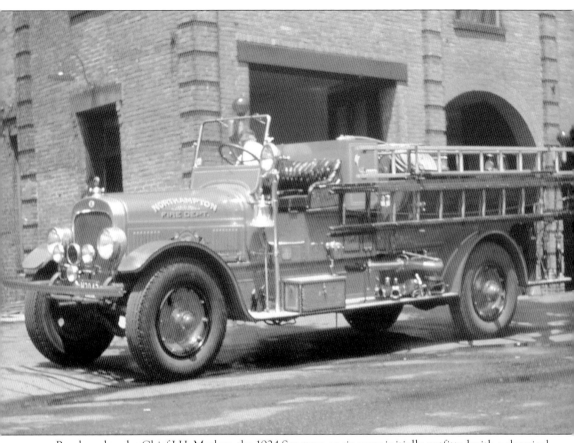

Purchased under Chief J.H. Marlow, the 1924 Seagrave engine was initially outfitted with a chemical tank when it first went into service, but it was later replaced with a 90-gallon water tank under orders from Chief Lucier sometime after 1929. The tank fed both a 1.5-inch hose and booster line. Here, it is pictured on the apron at the Masonic Street Station. (Courtesy of Northampton Fire Department Archives.)

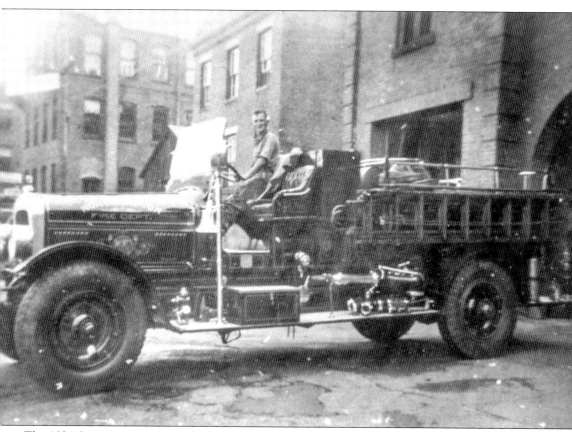

The 1924 Seagrave engine was the first motorized pumper in the department. It was equipped with a 750-gallon-per-minute pump. This photograph was taken in front of the Masonic Street Station with an unidentified fireman sitting behind the wheel. (Courtesy of Northampton Fire Department Archives.)

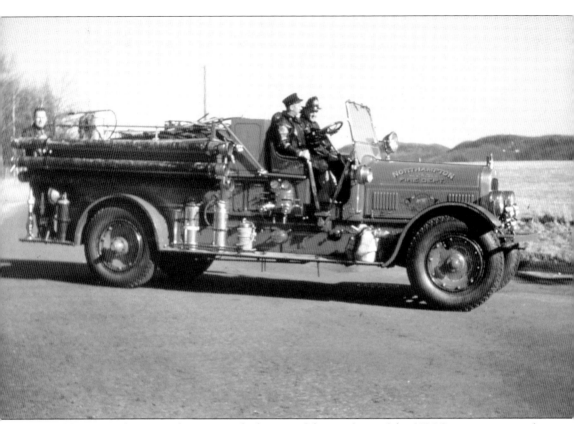

Alderman Robert Emrick was a vocal advocate of the purchase of the 1924 Seagrave engine after there was a delay in responding to a fire in Leeds, going so far as to visit the Holyoke fire chief to discuss that department's apparatus. Although Emrick thought the Seagrave would be best stationed in Florence, where there were permanent firemen, Chief John Marlow put it downtown at the Masonic Street Station. In this photograph, note the fireman riding on the backstep, a common practice for many years. (Courtesy of Northampton Fire Department Archives.)

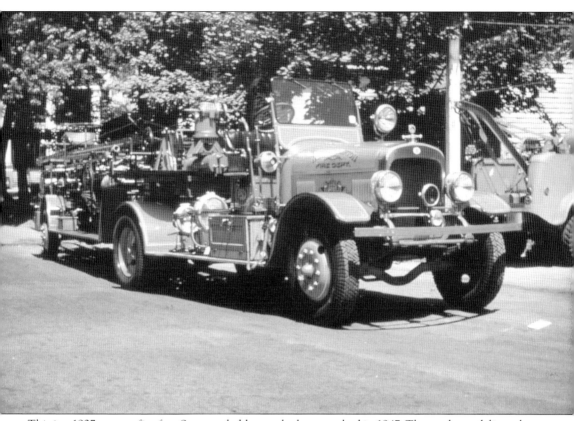

This is a 1927 seventy-five-foot Seagrave ladder truck photographed in 1947. The truck was delivered on March 8, 1928, and operated out of the Masonic Street Station, replacing the Pierce-Arrow, which was transferred to Florence. (Courtesy of Northampton Fire Department Archives.)

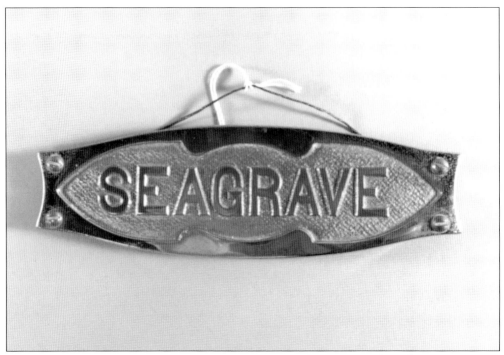

The embossed metal nameplate from the 1927 Seagrave ladder truck is in the collection at Historic Northampton. The 75-foot ladder truck was a tiller, steered from both the front cab and a jump seat in the rear. It was stationed out of the Masonic Street Station. (Courtesy of Historic Northampton.)

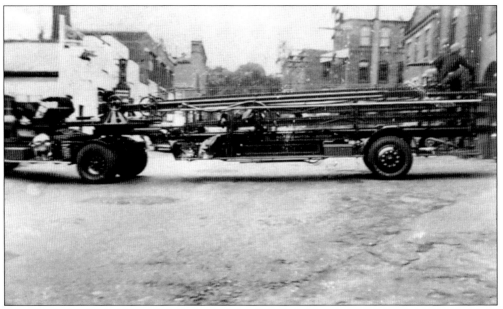

The ladder on the 1927 Seagrave extended to a length of 75 feet. The tillerman, sitting in a jump seat at the back of the truck, steers the rear wheels separately, helping the truck negotiate tight streets. Here, the driver and tillerman work in close coordination as they back a truck into the Masonic Street Station. (Courtesy of Northampton Fire Department Archives.)

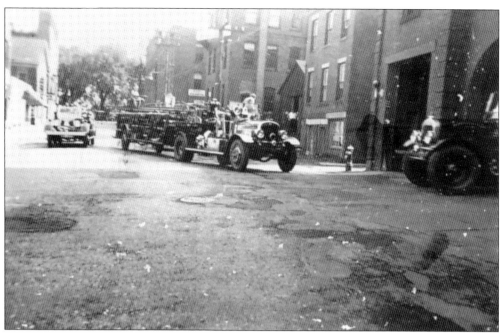

Masonic Street is a narrow side street off Main Street in the center of town. Firemen had to be skilled in order to maneuver apparatus in and out of the cramped bay doors, which were originally built for horse-drawn hose wagons. (Courtesy of Northampton Fire Department Archives.)

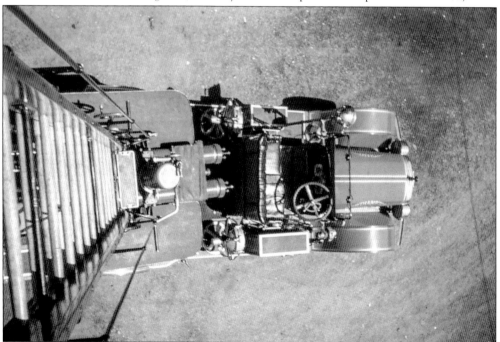

This photograph offers a unique perspective from the top of the extended ladder of the 1927 Seagrave ladder truck. The wooden ladders were very heavy and required several firemen to raise them from the bed and control them at the scene of a fire. (Courtesy of Northampton Fire Department Archives.)

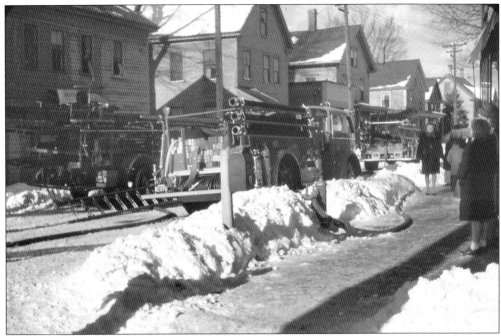

Bystanders watch the crews at a residential fire after a snowstorm. A 1946 American LaFrance engine, 1927 Seagrave ladder, and 1936 Buffalo engine No. 2 are on scene. (Courtesy of Northampton Fire Department Archives.)

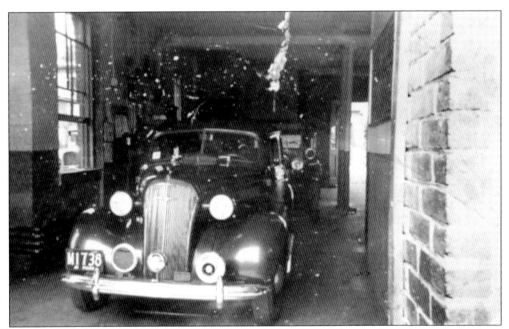

The far-left bay at the Masonic Street Station was reserved for the chief. Underneath the front bumper of the chief's 1937 Chevrolet, the cover to a cistern can be seen. In the background is the old 1924 Seagrave. The barn doors are swung wide open in both the front and rear of the station. (Courtesy of Northampton Fire Department Archives.)

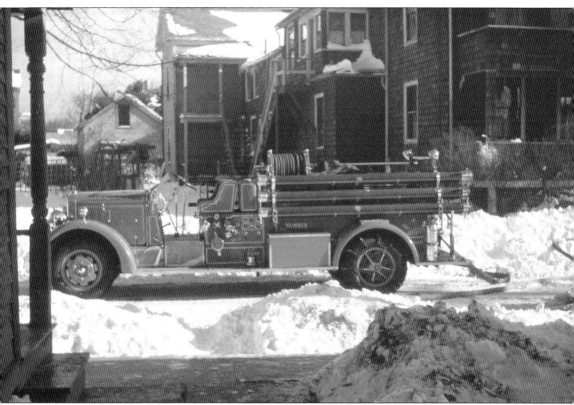

The 1936 Buffalo engine No. 2 is operating at the scene of a fire. There are snow chains on the tires and hose lines can be seen on the snow banks. (Courtesy of Northampton Fire Department Archives.)

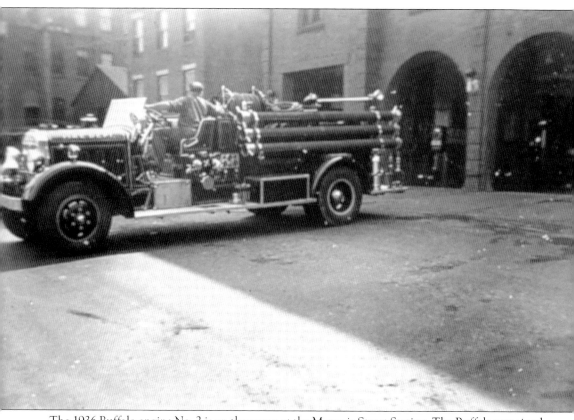

The 1936 Buffalo engine No. 2 is on the apron at the Masonic Street Station. The Buffalo remained in service until 1971, when it was sold for $777.77. (Courtesy of Northampton Fire Department Archives.)

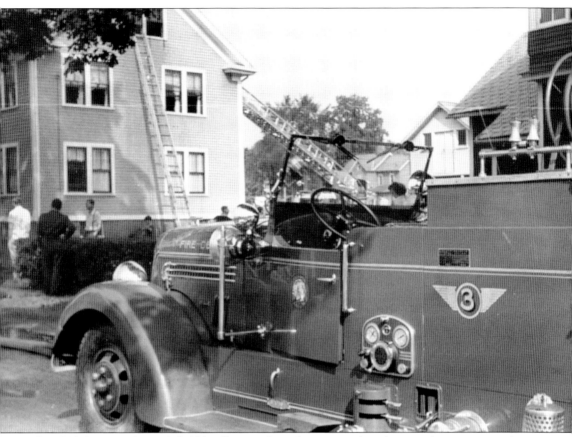

The 1940 Seagrave Series 170 600-gallon quad can be seen in this photograph operating at the scene of a fire. The 1952 Seagrave ladder No. 1 is in the background with its ladder extended to the second floor of a house. (Courtesy of Northampton Fire Department Archives.)

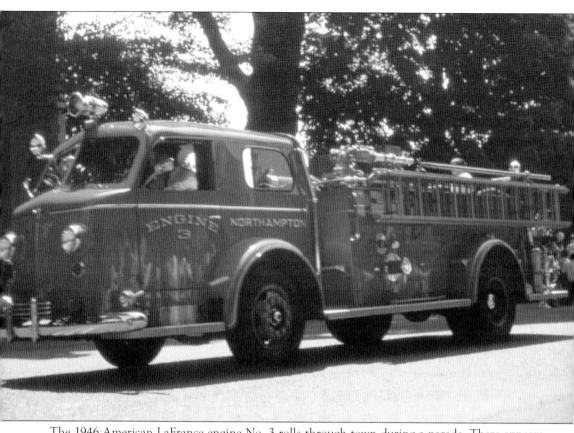

The 1946 American LaFrance engine No. 3 rolls through town during a parade. There appears to be a fireman riding on the backstep. (Courtesy of Northampton Fire Department Archives.)

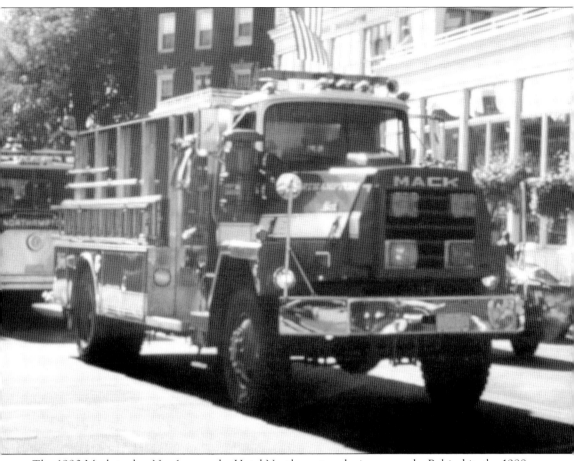

The 1990 Mack tanker No. 1 passes by Hotel Northampton during a parade. Behind it, the 1988 Mack engine No. 5 follows closely. (Courtesy of Northampton Fire Department Archives.)

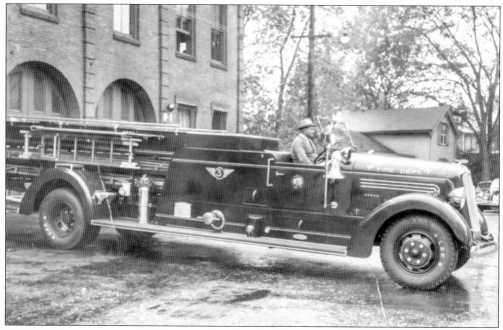

The 1940 Seagrave engine No. 3 was purchased on April 29, 1940, for $9,966.90. Here, it is pictured on the apron in front of the Masonic Street Station with an unidentified man in the operator's seat. (Courtesy of Northampton Fire Department Archives.)

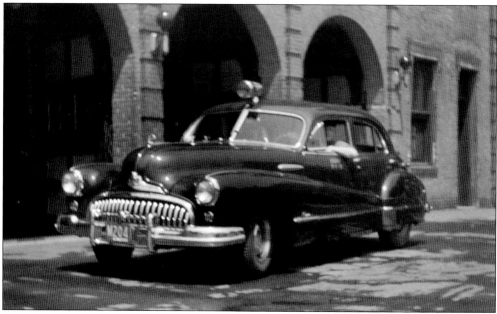

This 1948 Buick on the apron in front of Masonic Street Station would have been Chief C. Gerry Dalton's car. In April 1934, a young Gerry Dalton and Charlie Martin were injured when the fire truck they were using to respond to an alarm crashed into a parked car on Massasoit Street. They both went on to become chiefs of the department. In the background, note the original wood swinging doors that remained until they were replaced with metal roll up doors around 1950. (Courtesy of Northampton Fire Department Archives.)

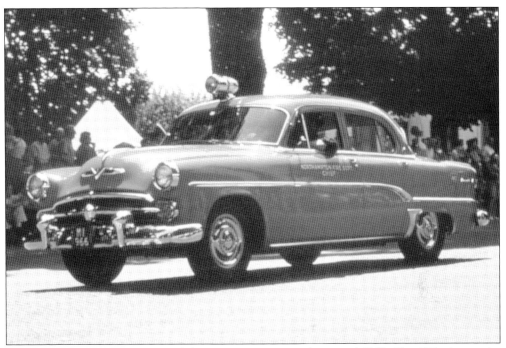

This 1954 Dodge, Chief E.J. Wright's car, is seen in a parade around 1955. Chief Wright ran the Northampton Fire Department from 1953 until 1956. (Courtesy of Northampton Fire Department Archives.)

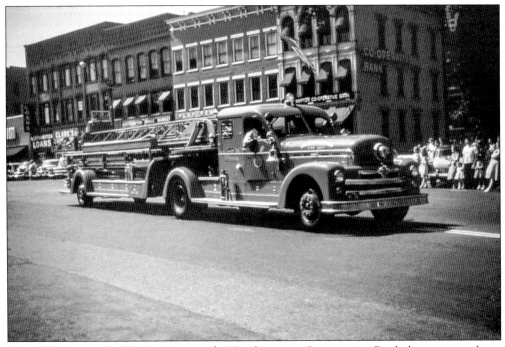

The 1952 Seagrave ladder No. 1 passes the Northampton Co-operative Bank during a parade on Main Street around 1962. Charlie Martin was the fire chief at the time. (Courtesy of Northampton Fire Department Archives.)

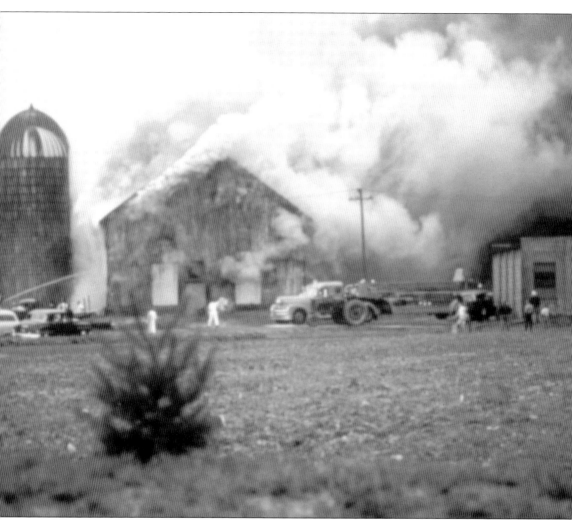

On May 21, 1960, ladder No. 1 responds to a barn fire at Northampton State Hospital. At far left, near the silo, hospital staff in white uniforms assist firemen with a handline. Twelve head of cattle were killed in the fire, which was suspected to be intentionally set. The estimated loss was $350,000. This was just one of a series of fires at the state hospital. In 1938, there was a small concrete block firehouse built on the property just off Prince Street to store firefighting equipment. Along with the other buildings on Hospital Hill, it was eventually demolished. (Courtesy of Northampton Fire Department Archives.)

PURCHASED BY
LUKE F. RYAN, MAYOR

BOARD OF ENGINEERS | FIRE DEPT. COMMITTEE
CHARLES G. DALTON, CHIEF | HANS J. GOLDSTAUB, CHAIRMAN
CHARLES E. MARTIN, 1ST. ASST. | WILLIAM F. SHEEHAN, COUNCILMAN
EDWARD J. WRIGHT, 2ND. ASST. | GEORGE F. McDONALD, COUNCILMAN
EDWARD J. RYAN, 3RD. ASST.

DATE OF PURCHASE: JULY 2, 1951

This plate was mounted on the 1952 Seagrave ladder No. 1. Charles G. Dalton was fire chief from 1947 until he retired in 1953 after 30 years of service. Second Assistant Chief E.J. Wright succeeded him until 1956, then First Assistant Chief Charles E. Martin went on to become chief in 1956, serving until 1969. (Courtesy of Northampton Fire Department Archives.)

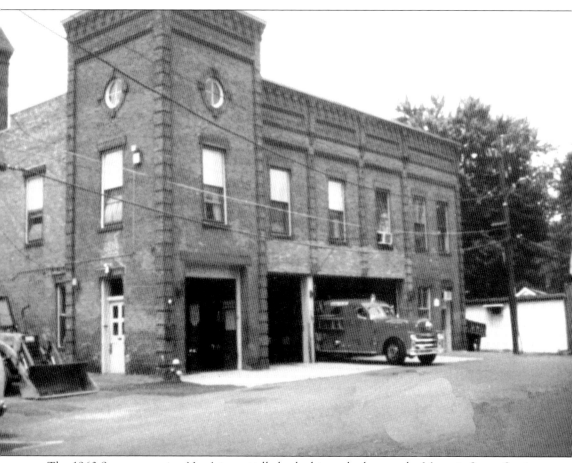

The 1960 Seagrave engine No. 1 is partially backed into the bay on the Masonic Street Station apron. Note the new brickwork above the bay doors after the Gothic arches and swinging doors were removed. The far bay was combined into an extra-wide door to facilitate larger modern fire apparatus. (Courtesy of Northampton Fire Department Archives.)

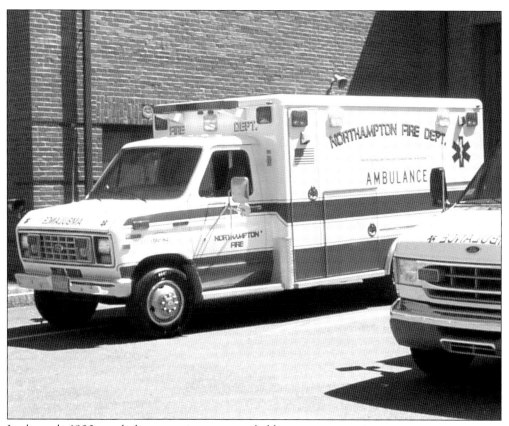

In the early 1900s, ambulance service was provided by Cooley Dickinson Hospital. Newell's and Gold Cross, private ambulance companies, also transported sick and injured people to the hospital during the early 20th century. Ambulance services were provided by the Northampton Fire Department from 1952 until 1968. Later on, Bay State Ambulance, Northampton Ambulance, and American Medical Response served the city. The fire department again took over full-time ambulance service in 2009 under Chief Brian Duggan. In this photograph, 60-A1 and 60-A2 can be seen on the apron at Northampton Fire Department Headquarters on Carlon Drive. (Courtesy of Northampton Fire Department Archives.)

As early as 1915, Northampton firemen, policemen, and members of the Cooley Dickinson Hospital Ladies Aid Society—50 people in all—received training on how to treat victims of drowning and asphyxiation with a pulmotor. This mechanical device weighed about 50 pounds and was kept in city hall. (Courtesy of Northampton Fire Department Archives.)

# Resuscitation

in

## Gas Poisoning
## Electric Shock
## and Drowning

A Manual of
### Standard Technique
with Explanatory Notes

Be prepared to save human
life through knowledge and
practice of this method.

1929

COUNCILLORS
AT LARGE
  William C. Ames
  Edward E. Keefe

WARD
  1 - Mario Mazza
  2 - Marion E. Mendelson
  3 - Peter Karparis, Jr.
  4 - Mary T. McColgan
  5 - Robert R. Patenaude
  6 - Charles W. Baranowski
  7 - Frances H. McNulty

CITY COUNCIL
# CITY OF NORTHAMPTON
MASSACHUSETTS

Minutes of the Fire Committee: December 10, 1976.

The Fire Committee of the City Council met on Friday December 10 at 4p.m. in the Fire Chief's office. The first item on the agenda was discussion of the first responder law which the state mandates must be in effect by July 1, 1977. A motion was made by Councillor McNulty to accept Mr. Richard Briere as the instructor of the necessary courses to be given to all firefighters. These courses will begin in January and will be held at the Northampton Fire Station.

Also discussed was space for the Fire Prevention Officer. Captain Jones has very little space in which to work and view plans. The Chief's office is used for this purpose and space is at a premium. The mayor, committee members and Chief viewed the second floor of the station to see if there was space available. The committee felt that as a start a plans table could be built by the CETA carpenter in the large room upstairs. Further work could be done as the need arose.

The possibility of another firefighter being trained in fire prevention was discussed so that someone would be available if Captain Jones was ill or on vacation. Requesting supplies for maintenance and cleaning from the city property committee was mentioned with the thought of requesting the necessary supplies well in advance of their use to insure availability.

The meeting was adjourned at 5:02 p.m.

*Mary T. McColgan*

In 1973, the Massachusetts Office of Emergency Medical Services was established, formalizing training and credentialing for emergency medical technicians. In Northampton, the adoption of these new policies was initiated under the Fire Committee. Initial training took place at the Masonic Street Station. (Courtesy of Northampton Fire Department Archives.)

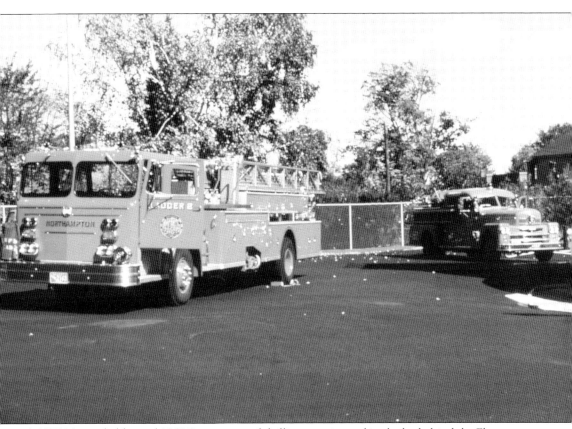

A 1976 Maxim ladder and 1960 Seagrave quad drilling are pictured in the lot behind the Florence Fire Station around 1976. On the right, a yellow hose line can be seen laid across the concrete drainage area of the newly built training tower. (Courtesy of Northampton Fire Department Archives.)

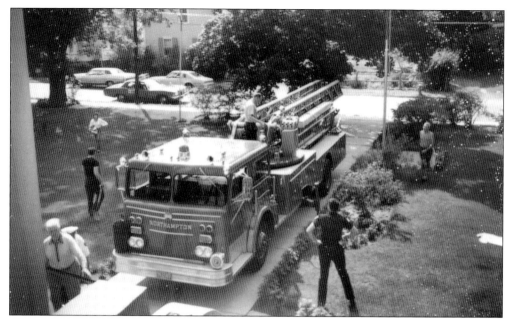

Crew from Ladder No. 2 are fixing the flagpole at the Hampshire County House of Corrections on Union Street in July 1982. The chief's 1972 Pontiac can be seen in the background. The 100-foot-long 1976 Maxim was delivered to the city in June 1976 at a cost of $99,500. This truck was in service until it was donated to the Milagro Fire Department in Ecuador in 2004. (Courtesy of Northampton Fire Department Archives.)

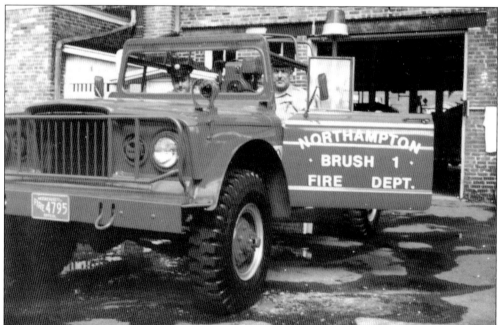

Northampton has a long history of grass fires that led to large losses. In this photograph, firemen are sitting in the 1967 Kaiser Jeep brush truck behind the Masonic Street Station. These off-road vehicles were necessary to get water to remote areas. This truck was purchased from surplus around 1980. (Courtesy of Northampton Fire Department Archives.)

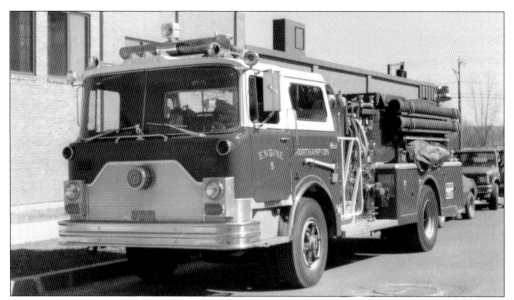

The 1988 Mack engine No. 5 operated out of the Florence Fire Station. It was one of two matching apparatus purchased at the same time. The other was engine No. 3, which was based at the Masonic Street Station. (Courtesy of Northampton Fire Department Archives.)

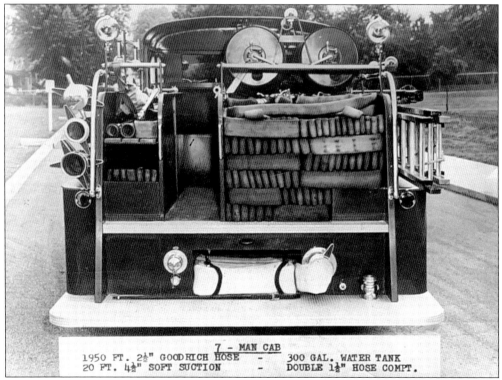

7 - MAN CAB
1950 FT. 2½" GOODRICH HOSE  -  300 GAL. WATER TANK
20 FT. 4½" SOFT SUCTION  -  DOUBLE 1½" HOSE COMPT.

How the hose is laid and the organization of tools on a fire apparatus is more of an art than science. This photograph of the rear bed of the 1960 Seagrave engine No. 1 was likely made for training purposes and shows the meticulous attention given to these matters. (Courtesy of Northampton Fire Department Archives.)

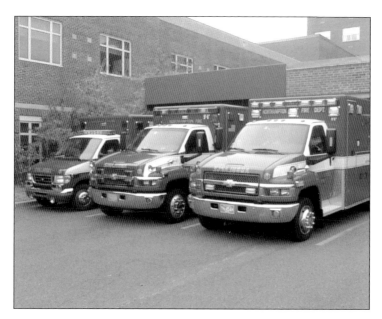

The Northampton Fire Department took over emergency medical services fully in 2009. Modern ambulances are much larger than earlier models to accommodate new equipment. These Northampton Fire Department ambulances are backed into the emergency department at Cooley Dickinson Hospital. (Courtesy of Northampton Fire Department Archives.)

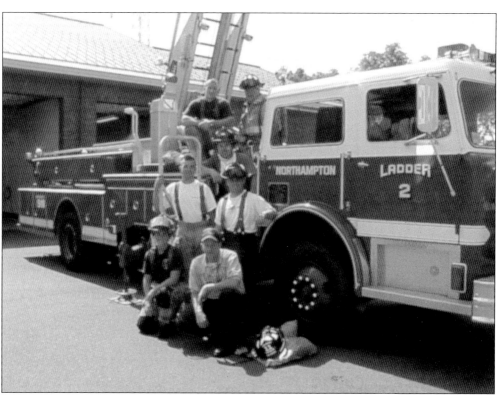

New recruits at Northampton Fire Department pose in front of ladder No. 2 in 2000. From left to right are (first row) Jen Brinn and training captain Duane Nichols; (second row) Dennis Nazzaro and John Garriepy; (third row) John Morriarty; (fourth row) Chris Norris and Matt Harrington. Chris Norris went on to become the Easthampton fire chief, and Captain Nichols became Northampton Fire Rescue chief. (Courtesy of Northampton Fire Department Archives.)

*Two*

# FIRE CHIEFS, OFFICERS, AND FIREFIGHTERS

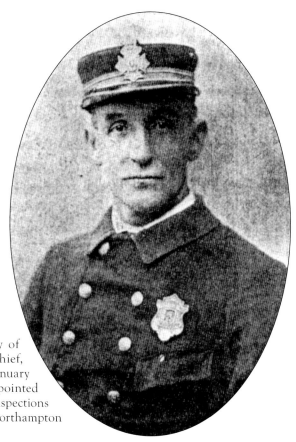

Frederic E. Chase served the City of Northampton for 40 years as fire chief, from 1899 until his retirement on January 5, 1920. This portrait of a newly appointed Chief Chase appeared in the 1899 Inspections and Field Day report. (Courtesy of Northampton Fire Department Archives.)

When he first started his service with the Northampton Fire Department in 1884, Fred Chase was assigned to Hose Company No. 7 under Chief Lewis Warner. At that time, the salary for firemen assigned to Florence, where Chase served until his appointment to chief, was just $18. This letterhead noting his rank as chief under the Office of the Board of Engineers is in the Northampton Fire Rescue archives. (Courtesy of Northampton Fire Department Archives.)

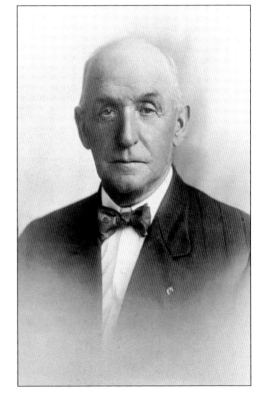

This portrait of Chief Chase later in his career still hangs on the wall at the Northampton Fire Rescue headquarters on Carlon Drive. He was promoted to Florence engineer in February 1897 under Chief George H. Daniels and appointed chief engineer by Mayor John L. Mather. Chief Chase passed away on November 4, 1925, at the age of 74. (Courtesy of Northampton Fire Department Archives.)

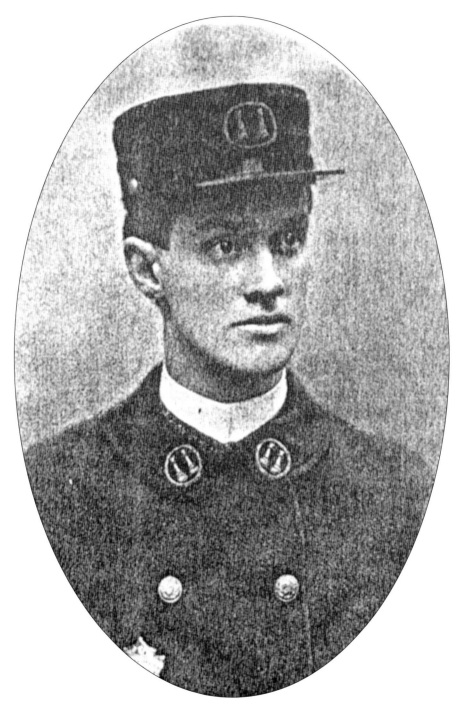

Capt. J.T. Lucier of Chemical A, Northampton Fire Department, was born in Northampton on August 31, 1868, and educated in area public schools. He was appointed a member of Hose No. 1, Northampton Fire Department, in 1897; acted as clerk and captain of Hose No. 1; and was appointed captain when the Chemical Company was formed. Captain Lucier went on to become chief engineer for the Northampton Fire Department from 1928 until 1939. (Courtesy of Northampton Fire Department Archives.)

– Suggested –

## Deceased Firemen

Frank Field–Leeds– died out of Service –
J. T. Hunt, " " "
John 2. Adams, " " "
Geo H Ray, " " "
Ira Dunning, " " "
Louis B. Sanders – died in service, – Leeds
Frank Barber, " " " Flame
Cornelius Van Dyke – " " " ..
Henry S. Gould, – " " " "
Thos Rothwell, " " " "
Paul Fitzgerald P. S. died out of Service – Bay
Garrett O'Brien P. S. died in Service – "
Chas S. Pratt died in Service, –
Gmy Duplain – " " "
Paul Lee, " " "
Chas Graves, " " "
Saml Day, " " "
Jos. T. Lucier – " " "
Philip Higgins " " "
Jas Nolan, died out of Service —
Geo Granger
Jas Eggleston,
John Dorsey
Herbert Bsworth,
Patrick Morrissey died in Service ..
Michael McDonald, " " ,

This undated list, titled "Deceased Firemen," was found in a logbook dated 1908. Twenty-six names fill the page, along with their station and whether they died in service or out of service. It may have been prepared ahead of one of the Firemen's Memorial Day ceremonies that take place on the second Sunday in June, when graves are decorated with flags and flowers after a service. (Courtesy of Northampton Fire Department Archives.)

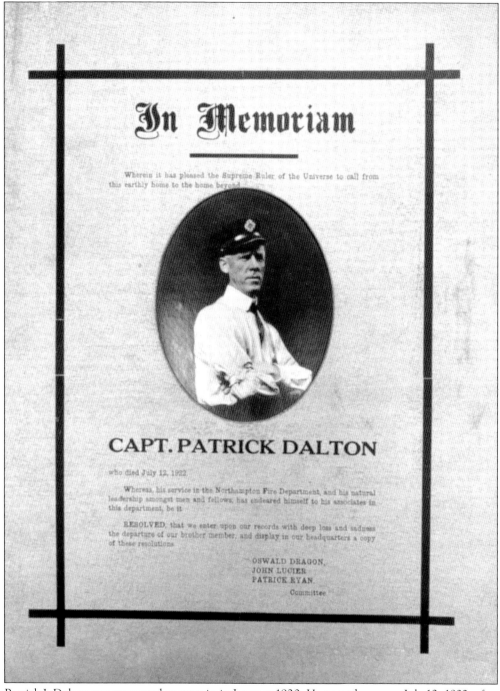

# In Memoriam

Wherein it has pleased the Supreme Ruler of the Universe to call from this earthly home to the home beyond

## CAPT. PATRICK DALTON

who died July 12, 1922

Whereas, his service in the Northampton Fire Department, and his natural leadership amongst men and fellows, has endeared himself to his associates in this department, be it

RESOLVED, that we enter upon our records with deep loss and sadness the departure of our brother member, and display in our headquarters a copy of these resolutions

OSWALD DRAGON,
JOHN LUCIER
PATRICK RYAN.

Committee

Patrick J. Dalton was promoted to captain in January 1920. He passed away on July 12, 1922, after a year-long battle with a brain tumor. His illness began after he struck his head while sliding down the pole at the fire station. Born in Leeds, he worked out of both the Florence Fire Station and Masonic Street Station. (Courtesy of Northampton Fire Department Archives.)

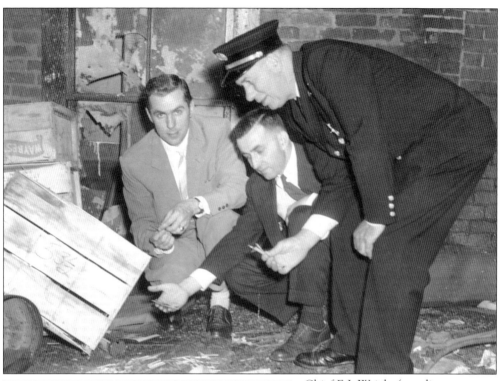

Chief E.J. Wright (standing at right) and Bernard Riley of the Massachusetts Office of the State Fire Marshal (center) investigate a suspicious fire around 1955. The man at left is unidentified. Robert F. Uln was the state fire marshal at that time, taking a leave of absence as chief of the Easthampton Fire Department in March 1953 and returning in 1958. (Courtesy of Northampton Fire Department Archives.)

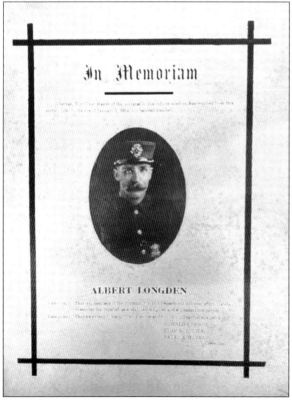

Fireman Albert Longden worked out of the Masonic Street Station. He passed away on January 1, 1914, of unreported causes. He was affectionately remembered as a zealous firefighter and pleasant companion. (Courtesy of Northampton Fire Department Archives.)

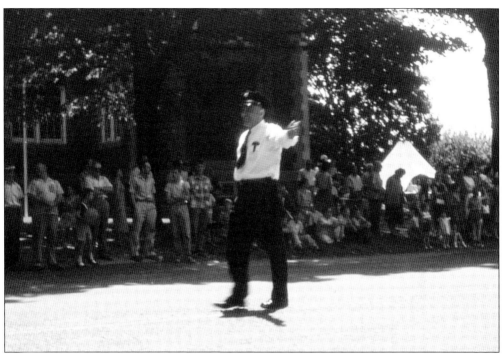

Chief Charles Edward Martin marches in a parade around 1962. Martin served the city for 41 years, from 1928 until retiring as fire chief in 1969 at the age of 65. (Courtesy of Northampton Fire Department Archives.)

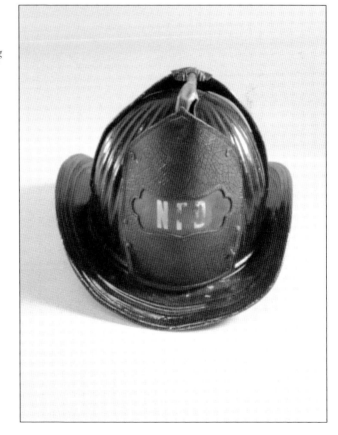

This fire helmet was worn by Chief Martin. Chief Martin. A lifelong resident of Northampton, Martin was born May 10, 1904, at 42 Warner Street. He later moved to Washington Avenue. (Courtesy of Historic Northampton.)

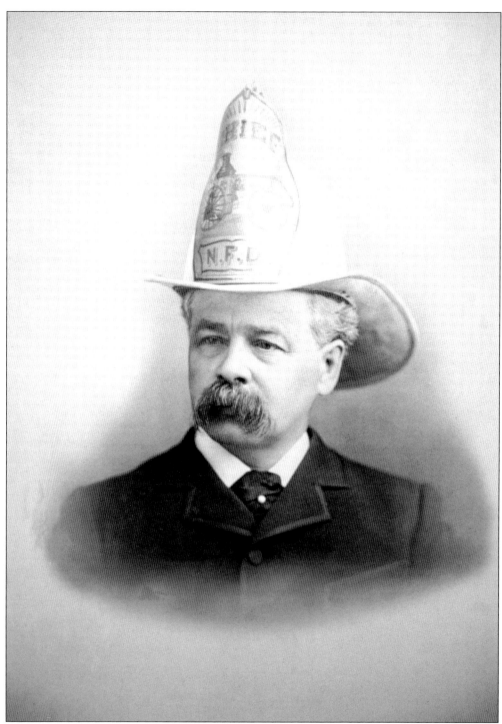

Lewis Warner was fire chief from 1877 to 1881 and again from 1883 to 1884. He came to Northampton in 1865 and worked his way from teller to president of the Hampshire County National Bank, while serving as Ward 3 alderman and treasurer of Hampshire County and even running for office as state treasurer. (Courtesy of Northampton Fire Department Archives.)

# $1000 REWARD.

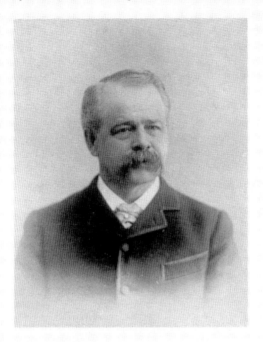

# LEWIS WARNER,

Who was President of the Hampshire County National Bank and Treasurer of the Hampshire Savings Bank, at Northampton, Mass. Missing since April 29, 1898, and wanted for embezzlement of the funds of both the above banks to a very large amount.

The Directors of the National Bank have offered the above reward for his arrest and conviction.

### DESCRIPTION.

Age, 58 years; height, about 5 feet, 4 inches; stout build; weight, about 165 pounds; complexion, light; dark blue eyes; gray hair and moustache; some false teeth; has the habit of throwing back his shoulders when walking; when sitting, often has one foot in chair under him; has large scar on side, result of operation for appendicitis.

Arrest, and notify U. S. Marshal at Boston, who has the warrant and is in charge of the case, or for further information inquire of

FORBES LIBRARY

J. E. CLARK, Sheriff of Hampshire County,

BENSON MUNYAN, District Police Officer,

HENRY E. MAYNARD, Chief of Police,

Northampton, Mass.

THE HELIOTYPE PRINTING CO., BOSTON

In 1898, it was discovered that Lewis Warner had embezzled $300,000 from various institutions. He fled for several months but was ultimately captured and convicted. He served a nine-year sentence in state prison, was released in 1908, and passed away at Cooley Dickinson Hospital in 1915 at the age of 74. He is buried in the Bridge Street Cemetery. (Courtesy Forbes Library.)

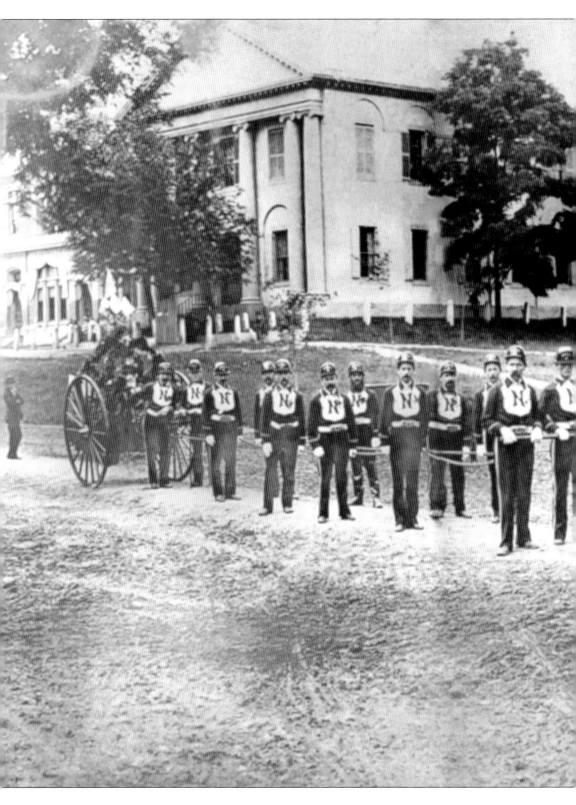

The Nonotuck Fire Company poses at a fire department muster on Main Street in 1878. Luther B. Askin (far right), of African American descent, was born on December 26, 1843, and lived in Florence for 80 years at 251 Nonotuck Street. He joined the Nonotuck Fire Company in 1870 and served for 20 years. Askin was an accomplished musician and played baseball with one of the first integrated teams in the country. His father ran the first livery stable in Florence, which likely gave Askin an important position in the firehouse as a hostler caring for the horses. In the early days of the fire service, horses were considered integral members of the team. (Courtesy of Forbes Library.)

MONTHLY ROLL CALL *Hose* COMPANY NO. 3

To the Engineers of the Northampton Fire Department

FOR THE MONTH *March 1 1902* 18

Use Letter P for present. A for absent. A. E for absent, excused

| NAMES OF MEMBERS | Regular Meeting | FIRE // | FIRE /4 | FIRE /5 | FIRE / | FIRE /8 | FIRE 2X | FIRE 28 | TOTAL |
|---|---|---|---|---|---|---|---|---|---|
| Capt. J C Black | / | / | | | | | | / | |
| Lieut. J. W. Walby | / | / | | | | | | / | |
| Clark & E. Graves | / | / | | | | | | / | |
| W, A. Burdick | / | / | | | | | | / | |
| S, A. Rice | / | / | | | | | | / | |
| G, H, Rverndam | / | / | | | | | | / | |
| J. W, Haukzley | / | | | | | | | | |
| G, I. Churchill | / | / | | | | | | | |
| J. Wood | / | / | | | | | | / | |
| B. L, Parsons | / | / | | | | | | / | |
| | / | | | | | | | | |

John C. Black of Florence began his career with the Northampton Fire Department around 1880, assigned to Hose Company No. 6 (along with Luther Askins). By 1899, he had been promoted to captain, as shown on this handwritten page from the fire department log. Black was also vice president of the Northampton Firemen's Relief Association. (Courtesy of Northampton Fire Department Archives.)

This page is from Captain Black's original rules and regulations book dated 1899. The handwritten inscription inside notes that it was the property of John Black, Hose Company No. 3. Captain Black served the City of Northampton for over 40 years. (Courtesy of Historic Northampton.)

# RULES AND REGULATIONS

FOR THE

## GOVERNMENT

OF THE

## NORTHAMPTON

# FIRE DEPARTMENT

ADOPTED MARCH 18, 1899

By the Committee on Fire Department and Board of Engineers

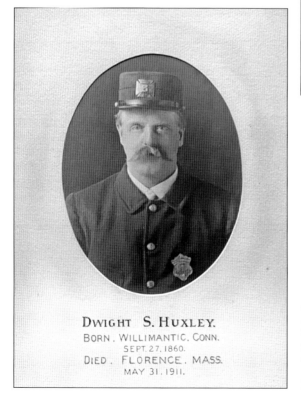

DWIGHT S. HUXLEY.
BORN. WILLIMANTIC. CONN.
SEPT. 27, 1860.
DIED. FLORENCE. MASS.
MAY 31, 1911.

This portrait of Dwight S. Huxley hangs in the Northampton Fire Rescue headquarters today. Captain Huxley was in charge of steamer No. 1 in 1905. (Courtesy of Northampton Fire Department Archives.)

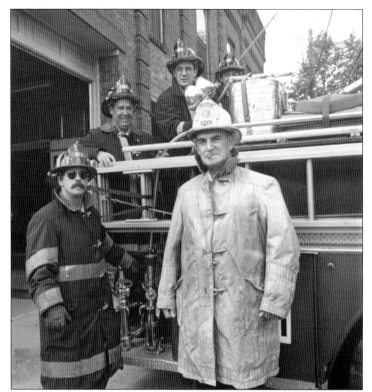

Chief Jeremiah Driscoll (in light-colored coat) and other Northampton firemen are standing on the apron in front of the Masonic Street Station in 1987. Driscoll joined the Northampton Fire Department in 1947, was promoted to captain in 1957, made deputy chief in 1970, and was appointed fire chief in June 1978 by Mayor Harry S. Chapman. Chief Driscoll retired in 1989. (Courtesy of Forbes Library.)

The first female firefighter appointed to the Northampton Fire Department was Tracy Driscoll in 1989. At 25 years old, Driscoll, the daughter of Chief Jeremiah P. Driscoll, was the sixth member of her family to serve the city. She retired from the Northampton Fire Department in 2017. (Photograph by author.)

The Northampton Firemen's Relief Association was officially incorporated in May 1883 with the mission to maintain a fund to be applied to the assistance and relief of members of the department who were injured in the course of firefighting or to assist the families of firemen who died in the line of duty. Lewis Warner was the first president of the Northampton Firemen's Relief Association. For its first several decades, the association would pay firemen who were injured and unable to work between $5 and $7 per week. (Photograph by author.)

The first annual ball by the Northampton Fire Department for the benefit of the Northampton Firemen's Relief Association was held in 1882, and for years, it was the primary funding source. Meetings for the association were held in the basement of the button factory building owned by Lewis Warner, two doors over from the Masonic Street Station. The Northampton Firemen's Relief Association was dissolved around 2010. (Courtesy Northampton Fire Department Archives.)

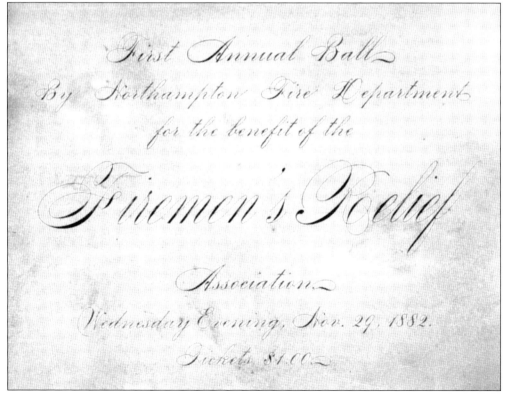

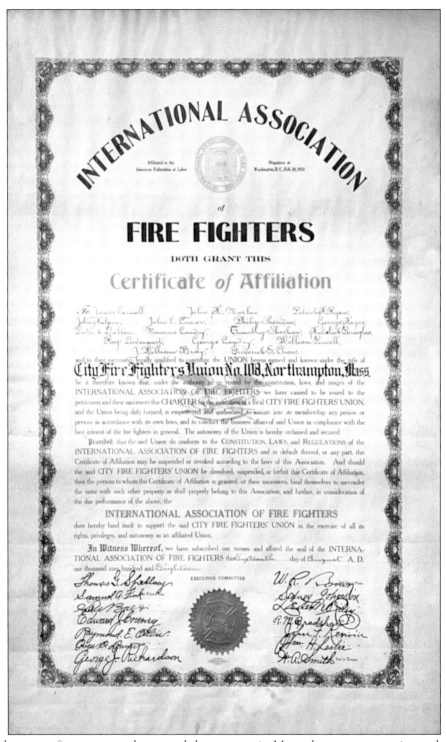

Northampton firemen were the second department in Massachusetts to organize under the International Association of Fire Fighters. Local No. 108 was recognized on August 16, 1918. The Cambridge Fire Department (Local No. 30) was first in Massachusetts. (Photograph by author.)

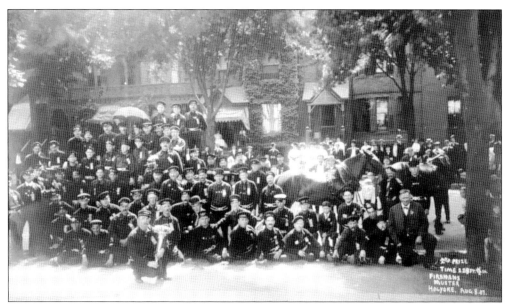

During musters, teams of 10–12 firemen would pump water from the cisterns challenging other fire departments to see how far a stream could be thrown, how high it could go, or how accurately a crew could hit a target. Winning departments collected cash prizes of up to $300. Teams would come from as far as Holyoke and Westfield, loading their apparatus on flat railcars. The North Adams Fire Department muster crew transported their pumper through the Hoosac Tunnel to come to Northampton. The guest firemen would be greeted by a marching band and escorted to Main Street for the Saturday musters. This photograph was taken at a muster in Holyoke, where Northampton firemen took second prize on August 8, 1907. (Courtesy of Historic Northampton.)

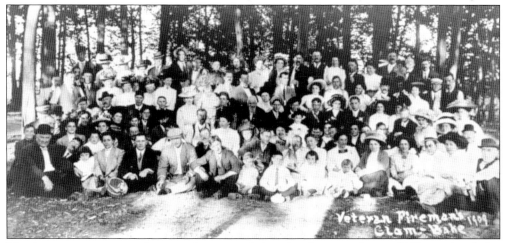

This large group portrait of veteran firemen and their families was taken in 1909 at a clam bake. On reverse is written, "Great Grandfather Ed Martin Jr. (Charles Martin's father, grandfather—Ed Martin) 2nd row from top—with moustache—arrow pointing to him." Chief Martin began his career with the Northampton Fire Department on March 15, 1928, and worked his way through the ranks. He was appointed by Mayor Cahillane as fire chief on June 10, 1956. He was the fire chief until he turned 65 in 1969; he had been at Northampton Fire Department for a total of 41 years. Chief Martin passed away on January 3, 1983, at the age of 77. His son Edward C. Martin also served with the department. (Courtesy of Historic Northampton.)

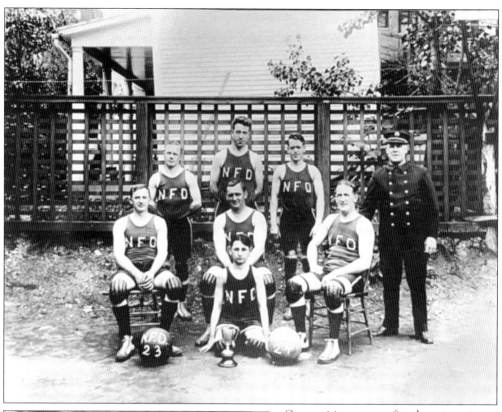

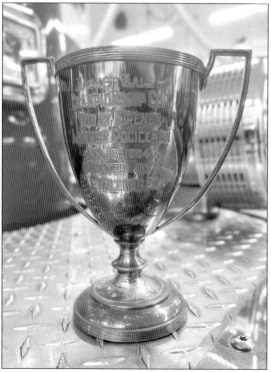

Competition among fire department companies and between the fire and police departments has always been part of the Northampton Fire Department culture. In this photograph from 1924, seven firemen pose in basketball uniforms with a trophy. (Courtesy of Historic Northampton.)

That trophy is still on display at the Northampton Fire Rescue headquarters. The inscription reads, "Basket Ball Championship Cup. Won by Firemen against Policemen. Jan. 18, 1924. Donated by A. Welcome." (Photograph by author.)

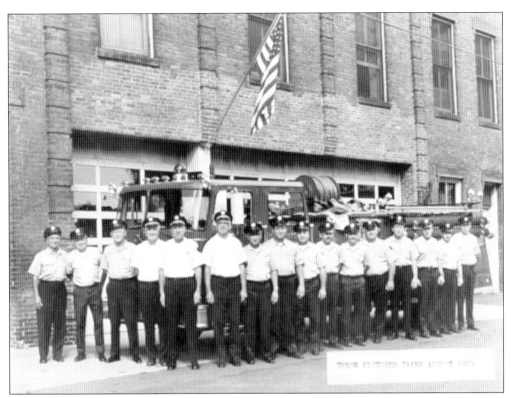

Members of A Group pose for a portrait in front of the
Masonic Street Station in August 1972. Behind them is
the 1969 Maxim engine No. 5. Chief J.C. Murray was
in charge of the department at that time. (Courtesy of
Northampton Fire Department Archives.)

We A&P Care

BEST WISHES From Your
A&P MANAGER & CLERKS

160

A fireman quickly changes out his duty shoes
and dons hip boots before heading out on a call.
His long turnout coat and metal helmet are ready
to go. This photograph appeared in the 1977
Firemen's Ball program and was sponsored by local
businesses. (Courtesy of Historic Northampton.)

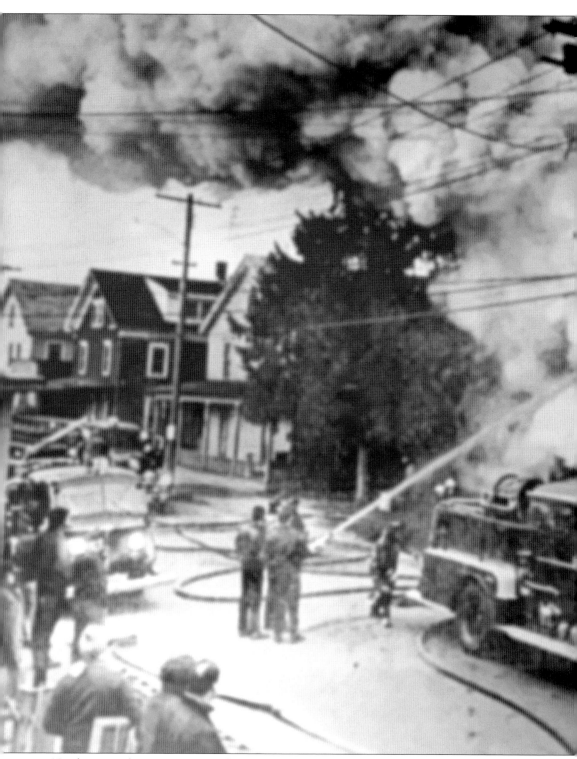

Northampton firemen are pictured working at a residential structure fire around 1977. The 1960 Seagrave engine No. 1 is out front. At left is the 1946 American LaFrance engine No. 3, and the

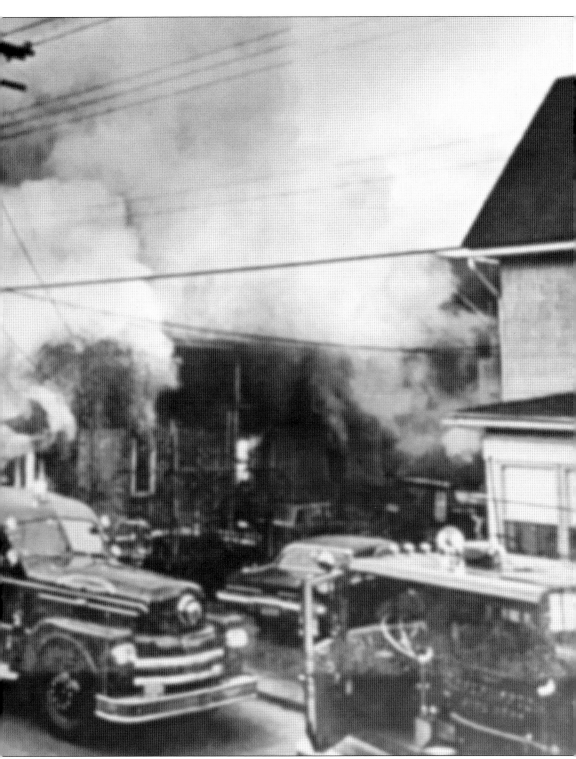

1952 Seagrave No. 1 is in the background. The 1976 Maxim ladder No. 2 is staged to the right. (Courtesy of Northampton Fire Department Archives.)

IN MEMORY OF

JOHN HURLEY

WHO WILL BE REMEMBERED AS AN
ACTIVE MEMBER, DEPUTY FIRE CHIEF,
AND AN OUTSTANDING AMERICAN
MAY HIS PRINCIPLES OF SUCCESS
AND ENCOURAGEMENT BE AN
EXAMPLE TO ALL

PRESENTED BY
WORLD WAR II VETERANS ASSOC
HAMPSHIRE COUNTY

OCTOBER 17 1970

Deputy Chief John N. Hurley was killed in a car accident while driving back from a vacation in South Carolina. His wife was seriously injured. He was the son of Chief Thomas W. Hurley. His funeral was in Northampton on March 11, 1969, with full fire department honors. (Photograph by author.)

The hat badge on the left is stamped by the C.G. Braxmar Company. The New York company began manufacturing badges in 1879. The badge on the right belongs to the author. (Photograph by author.)

# Proclamation

### CITY OF NORTHAMPTON
### COMMONWEALTH OF MASSACHUSETTS

WHEREAS: Fire Fighting is the single most hazardous profession in the nation, and

WHEREAS: Fire Fighters have continuously shown a dedication and spirit of sacrifice to the people of the Commonwealth of Massachusetts, and

WHEREAS: It is both fitting and proper that the memory of these brave men should be honored

NOW, THEREFORE, I, HARRY S. CHAPMAN, JR., as Mayor of the City of Northampton proclaim June 10, 1979 as

FIRE FIGHTERS MEMORIAL SUNDAY

and urge all the citizens of this City to be cognizant of this event and to participate fittingly in its observance.

Mayor

The second Sunday in June has been Firemen's Memorial Day since 1909 across the commonwealth to honor all those departed. On June 10, 1979, Mayor Harry S. Chapman recognized the "dedication and spirit of sacrifice" of the Northampton Fire Department. (Courtesy of Northampton Fire Department Archives.)

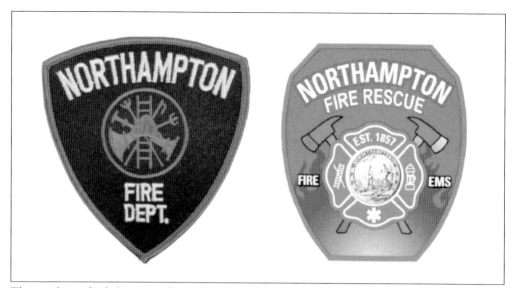

The patch on the left was used into the 1970s by the Northampton Fire Department. Around 2015, the name Northampton Fire Rescue was officially adopted by the department to reflect the services provided beyond firefighting. (Photograph by author.)

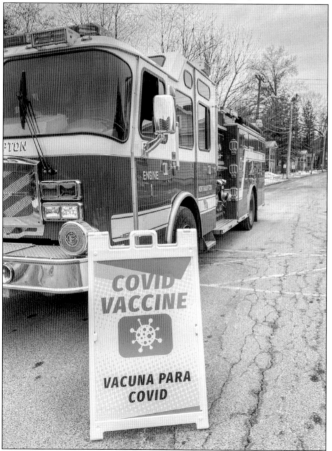

In 2020, as the COVID-19 pandemic impacted Northampton and the surrounding communities, Northampton Fire Rescue paramedics partnered with other city agencies to deliver vaccines to the public, while still providing response to fires and medical emergencies. In 2022, Northampton Fire Rescue responded to over 8,000 emergency calls. (Photograph by author.)

# *Three*

# FIRE STATIONS

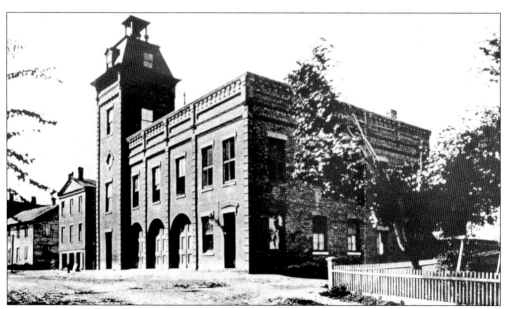

The Masonic Street Fire Station was built in 1872. This photograph, taken around 1890, shows the original configuration of the firehouse with the five-story hose tower and bell on the front of the station and three bays with swinging doors. The bars on the windows of the jail can be seen on the right side of the building. (Courtesy of Northampton Fire Department Archives.)

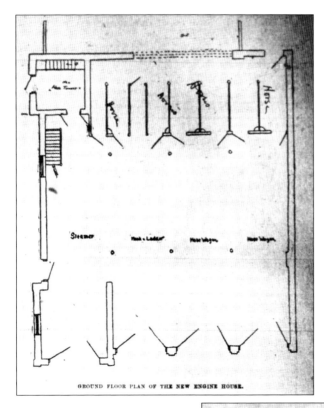

GROUND FLOOR PLAN OF THE NEW ENGINE HOUSE.

This sketch of the new station upgrades made in 1892 shows the additional bay door on the left front of the building, with a straight stone lintel in contrast to the Gothic arches of the other three bays. Another major change was to move the hose tower and bell from the front of the station to the rear right corner; the new tower stood 74 feet high. A new bell was installed in 1893. (Courtesy *Hampshire Gazette*.)

The Bay State Station on Riverside Drive was in service from 1865 until 1950. The structure was destroyed by fire on December 16, 1870, but rebuilt. Initially, it housed Engine Company No. 4 and a hose company with 1,000 feet of hose. The building was owned by Northampton Cutlery and loaned to the city, as were the horses that pulled the apparatus. It was staffed by 10 call men, who were primarily workers from the factory. Additional horses were brought in from Howes Brothers across the street if needed. (Courtesy of Forbes Library.)

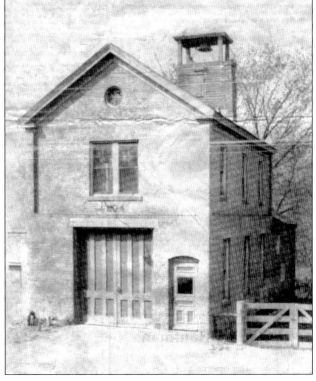

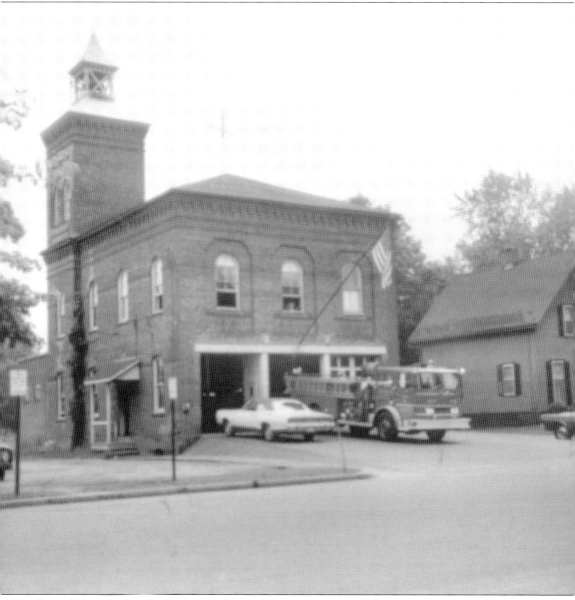

The 1969 Maxim engine No. 5 is seen here in front of the original Florence Fire Station. Note the swinging barn doors that accessed the apparatus floor. The relatively steep grade of the apron is also clear from this perspective. This station was razed just a few years later and a new one built on the same lot at 69 Maple Street two years after that. (Courtesy of Northampton Fire Department Archives.)

A personal vehicle, likely belonging to an officer, is parked on the apron of the Florence Fire Station around 1970, shortly before it was razed to make room for the new building. The doors had been changed from the original Gothic arches but still appear to swing. The bell still appears to be hung in the tower. (Courtesy of Northampton Fire Department Archives.)

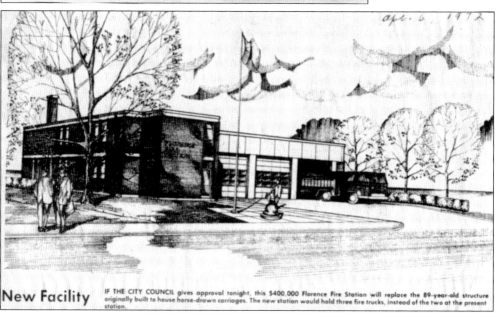

**New Facility** IF THE CITY COUNCIL gives approval tonight, this $400,000 Florence Fire Station will replace the 89-year-old structure originally built to house horse-drawn carriages. The new station would hold three fire trucks, instead of the two at the present station.

The new Florence Fire Station was dedicated on June 3, 1973, by Mayor Sean M. Dunphy in a ceremony attended by about 100 people. It was built at a cost of $375,000 under the leadership of Chief James C. Murray. This drawing is from the cover of the dedication program. (Courtesy of Northampton Fire Department Archives.)

The new Florence Fire Station was built with three apparatus bays and separate crew quarters on the second floor. A three-story concrete training tower with drainage and hydrants behind the station provided an area for live fire drills. (Photograph by author.)

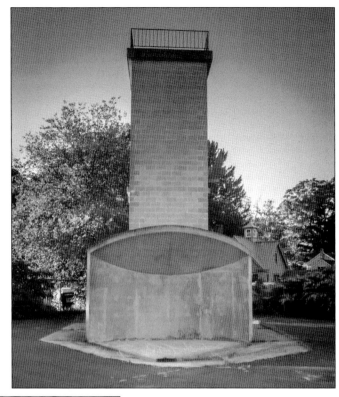

The director of the Leeds Veterans Administration Hospital, Dr. James L. Benepe, presented this commemorative flag to Chief Murray during the opening ceremony of the new Florence Fire Station. The accompanying letter from Congressman Silvio O. Conte dated November 3, 1972, confirms that the flag had been flown over the US Capitol. (Photograph by author.)

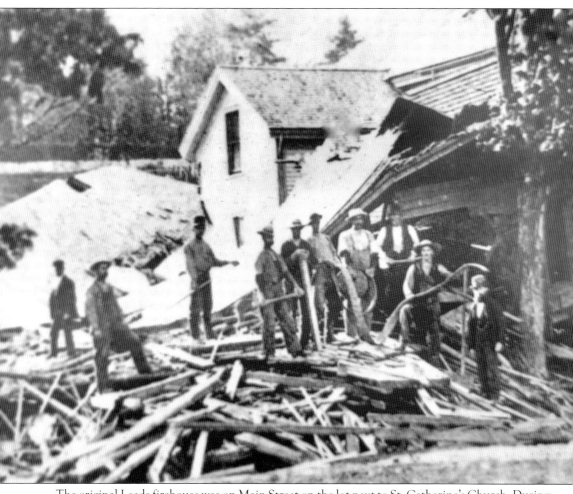

The original Leeds firehouse was on Main Street on the lot next to St. Catherine's Church. During the dam failure and flood of 1874, it was pushed 50 feet off its foundation and into a tree and house by the raging Mill River. (Courtesy of Forbes Library.)

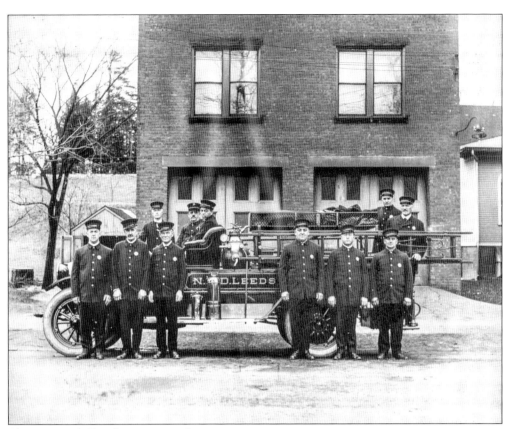

The new Leeds Fire Station opened in 1900 and remained in service until 1973. It was razed in 1975. In this photograph, the Leeds Company is posing in front of the 1919 REO engine around 1919. This was the first motorized apparatus put into service in Leeds. (Courtesy of Forbes Library, Robert P. Emrick Collection.)

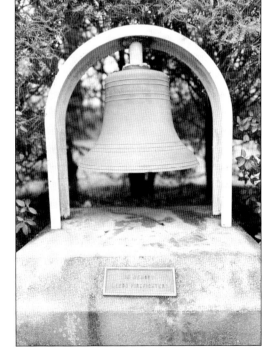

The original bell that hung in the Leeds Fire Station tower was cast in 1886. It is now on display at Leeds Memorial Park. The plaque reads, "In Memory / Leeds Firefighters." (Photograph by author.)

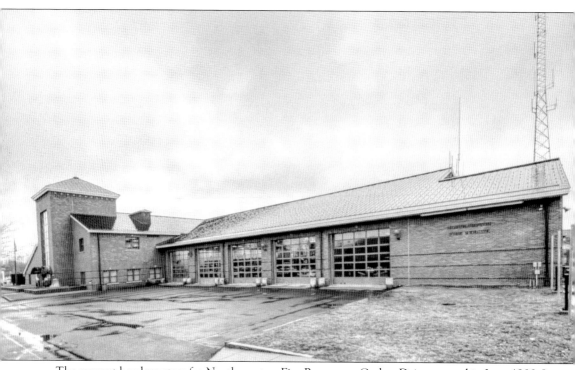

The current headquarters for Northampton Fire Rescue on Carlon Drive opened in June 1999. It was built at a cost of $5.5 million. The Masonic Street Station closed later that same year after 127 years of service. The bell from the old tower adorns the entrance of the new station. (Photograph by author.)

# *Four*

# HISTORIC FIRES

Early on the morning of July 19, 1870, one of the most destructive fires in Northampton history broke out at the Warner House on Main Street and the adjoining Lyman wooden block to the west (the current location of TD Bank). The weather was reported to be mild, which likely led to the throngs of people who gathered to watch the Northampton firemen battle the blaze for more than four hours. The new steamers had been delivered just 10 days before the fire but had not gone into service yet. They were brought to the scene, but firemen had trouble operating them. The loss was estimated at $100,000. (Courtesy of Northampton Fire Department Archives.)

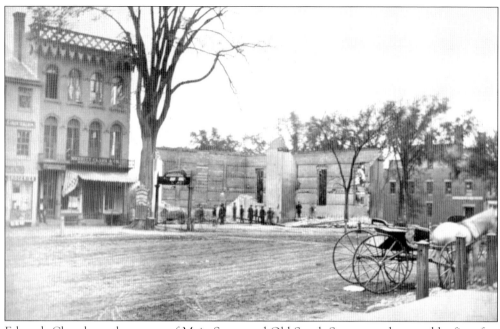

Edwards Church on the corner of Main Street and Old South Street was destroyed by fire after the Hunt's Building next door went up in flames on May 19, 1870, at around 11:00 p.m. It was suspected that the fire started in Hannum and Everett, a manufacturer's shop on the second floor in the rear of the building. The flames spread rapidly throughout the wood-framed building and then through the roof before reaching the church. Bystanders helped remove items from the businesses and the church while the fire department positioned its apparatus. The church was built in 1833 at a cost of $10,600. The organ inside was valued at $4,000, and the estimated replacement cost was twice that. The blaze was reported widely as the most destructive fire in many years. The total loss was estimated at $50,000. The church was rebuilt at its current location at Main and State Streets. (Above, courtesy of Historic Northampton; below, courtesy of *Northampton: The Meadow City*.)

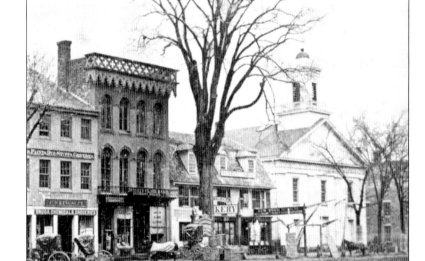

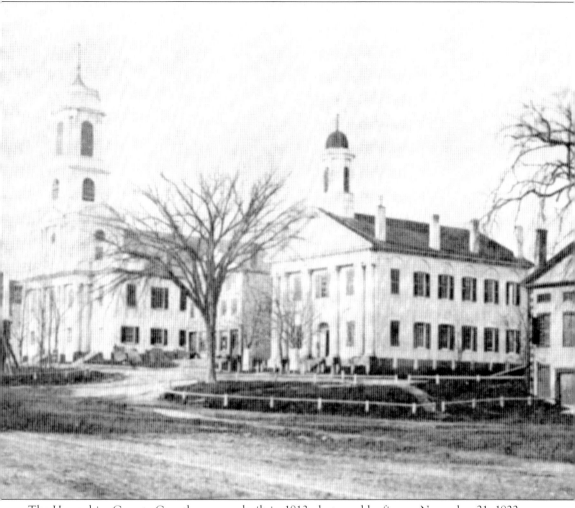

The Hampshire County Courthouse was built in 1813, destroyed by fire on November 21, 1822, and rebuilt the following year at the same location. The current courthouse was built in 1886–1887. This photograph of the Old Church and the rebuilt courthouse was taken in 1864 before the church was destroyed by fire in 1870. (Courtesy of *Reminiscence of Old Northampton*.)

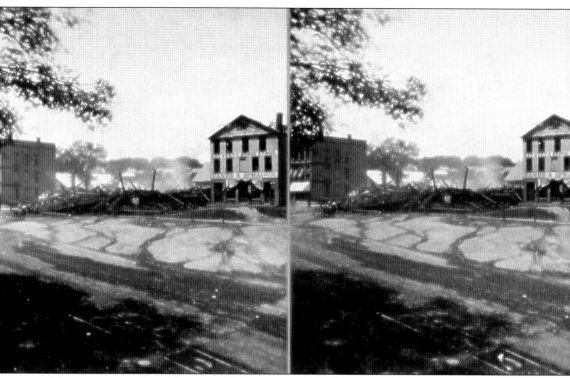

This stereo view shows the ruins of the First Congregational Church and Whitney Building on Main Street after the June 27, 1876, fire. (Courtesy of Historic Northampton.)

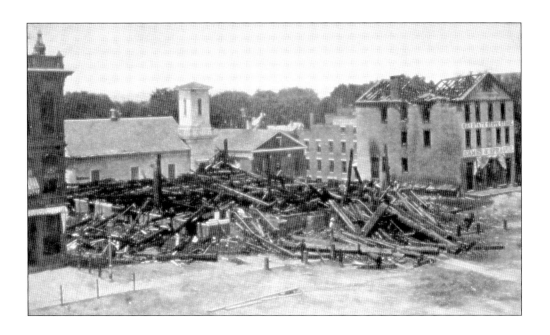

Built in 1811–1812, the First Congregational Church on Main Street was totally destroyed by fire on June 27, 1876, a reported $40,000 loss. The courthouse next door sustained major damage as well. Built by Capt. Isaac Damon and known as the Old Church until it was destroyed, it was the largest church in New England. The church was rebuilt in 1877 and still stands today. (Both, courtesy of Historic Northampton.)

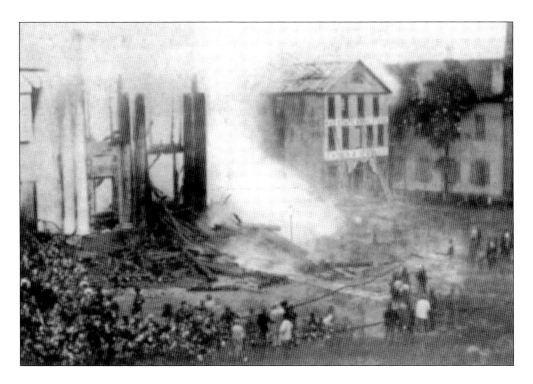

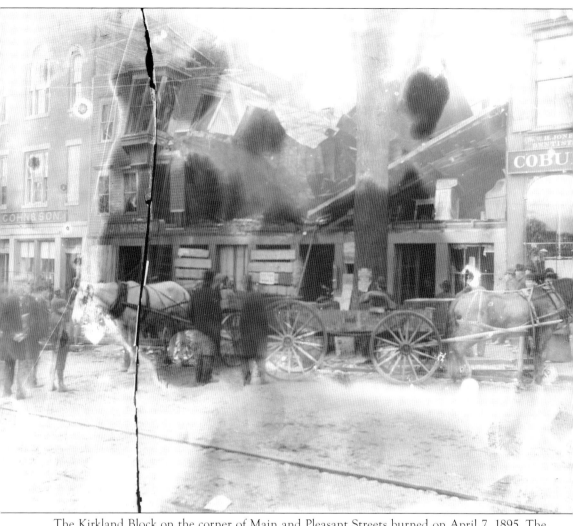

The Kirkland Block on the corner of Main and Pleasant Streets burned on April 7, 1895. The three-story wood building was occupied by retailers and offices and used for the storage of dry goods. At the time, it was one of the oldest structures in the city, built by Benjamin Prescott in 1786. (Courtesy of Historic Northampton.)

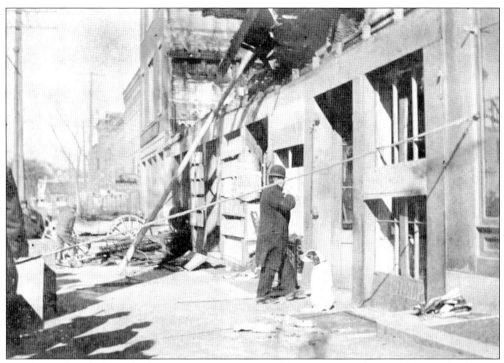

Joseph Marsh, a dealer in books, stationery, pictures, and frames, occupied one of the street-level stores in the Kirkland Block. At right is the Holyoke Bank. The Kirkland Block was replaced with the Lambie Block, better known as the Nonotuck Savings Bank building. (Courtesy of Historic Northampton.)

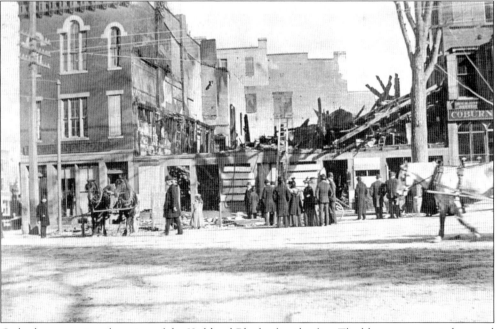

Onlookers examine the ruins of the Kirkland Block after the fire. The blaze was reported around 11:00 p.m. by a passerby, and all hands responded. Losses were estimated at $25,000. (Courtesy of Historic Northampton.)

Leeds
Bell.

Friday Dec 11th at 7 a.m. the bell rang for a fire in house owned & occupied by Joseph Versaille 124 Water St Leeds near the old reservoir out of reach of a hydrant necessitating the use of the old hand tub to which 56 men pumped heroically for two consecutive hours

Value of building 2000.     Value of Contents – 1000.
Ins on building 1,000.     Ins on Contents 500.00
Loss to building 846.00    Loss on Contents 500.00

This report from December 11, 1908, gives a sense of how hard the Northampton Fire Department worked at that time at a fire in Leeds: "Friday Dec 11th at 7 a.m. the bell rang for a fire in a house owned and occupied by Joseph Versaille 24 Water St Leeds near the old reservoir out of reach of a hydrant necessitating the use of the old hand tub to which 56 men pumped heroically for two consecutive hours." (Courtesy of Northampton Fire Department Archives.)

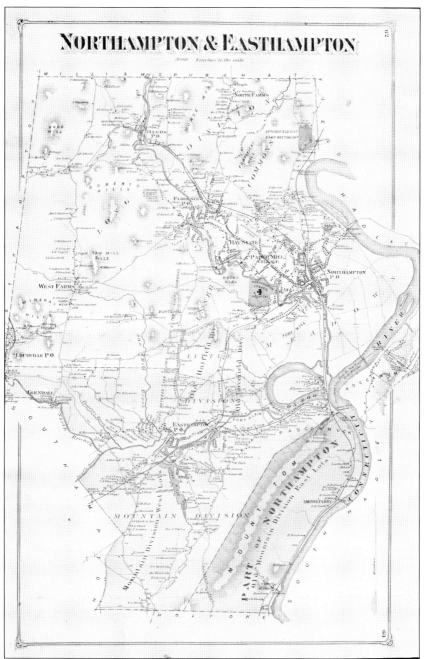

The Smith's Ferry section of modern-day Holyoke was once part of Northampton, but since the roads in the area of the Oxbow were prone to flooding, the Northampton Fire Department was often not able to respond to alarms in that neighborhood, leaving the responsibilities to the Holyoke Fire Department. This was an ongoing topic of discussion in both cities' newspapers but reached a fever pitch after sparks from a passing train caused a brush fire that resulted in the total loss of the Holyoke Canoe Club on March 21, 1909. A few months later, Smith's Ferry was officially annexed by Holyoke at a cost of $62,000 paid to Northampton. (Courtesy County Atlas of Hampshire, Massachusetts, 1873.)

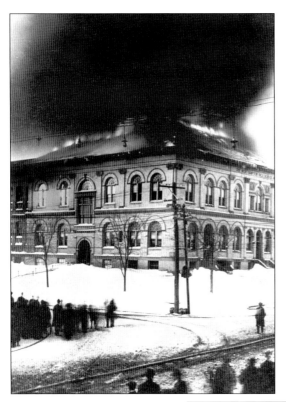

The original Northampton High School on the corner of Main Street and South Street, across from the Academy of Music, was built in 1895 at a cost of $60,000. It was destroyed by fire on the afternoon of Sunday, February 24, 1914. Box 24 was struck, and all hands responded under the leadership of Chief Chase. Horses had to be brought over to the Masonic Street Station from Wade Movers before the Silsby steamer could be brought to the blaze. Deep snow hampered efforts in getting the Tappan to the scene. Firemen Havelock Purseglove and Carnell narrowly escaped being caught in the building when the roof collapsed. The building was not insured. (Courtesy of Forbes Library.)

The First National Bank at the intersection of Main and King Streets was destroyed by a fire on January 17, 1895. The first floor of the building was also home to the offices of the American Express Company. On the second floor were the law offices of Hammond and Mason. There was a print shop on the top floor. The fire started in a wall on the first floor. The loss was estimated at $20,000. The Silsby steamer can be seen cranking away and producing a plume of black smoke. (Courtesy of Forbes Library.)

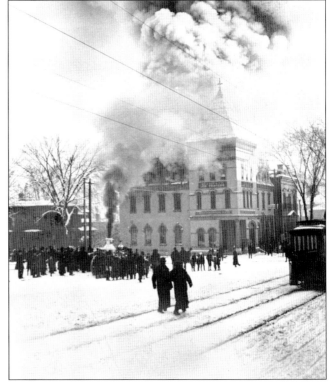

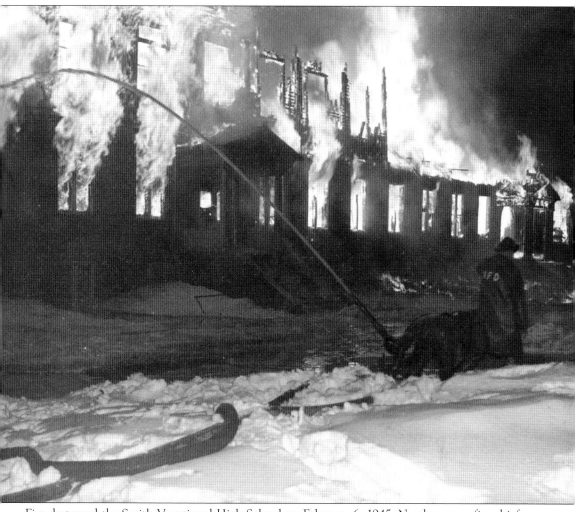

Fire destroyed the Smith Vocational High School on February 6, 1945. Northampton fire chief Patrick Ryan estimated the loss at $200,000. The fire started in the paint room, and crews were hampered by low water pressure from the hydrants on campus, which could not reach the second floor of the three-story building. (Courtesy of Forbes Library.)

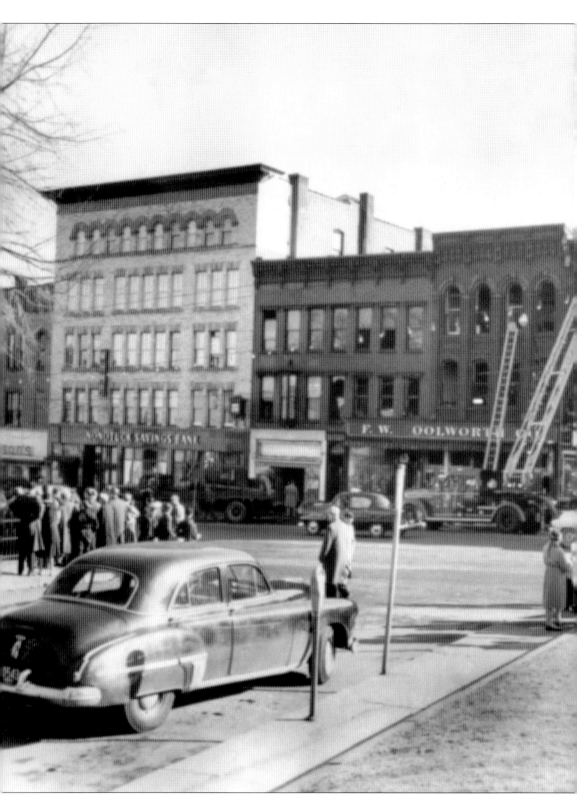

On New Year's Day 1955, the Woolworth store at 86 Main Street, across from the courthouse, burned. Northampton firemen under Chief Edward J. Wright battled the fire for more than seven hours, along with help from the Easthampton and Holyoke Fire Departments. Damage was estimated at $750,000. (Courtesy of Northampton Fire Department Archives.)

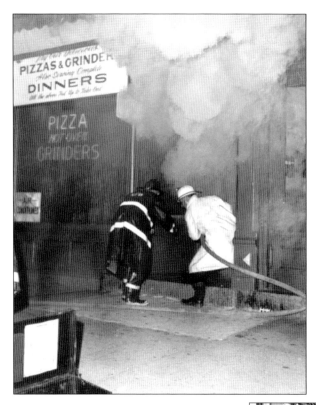

Deputy Fire Chief Jeremiah Driscoll and Pvt. Victor Gaudet are attempting to make entry into a structure fire in the pizza shop at 92 Maple Street on June 23, 1971. Fire Chief James Murray reported the fire started in the basement and caused damage to stores and apartments in the entire block. In 1902, the same block was the location of the Florence Post Office, a newspaper store, and a tailor. (Courtesy of Historic Northampton.)

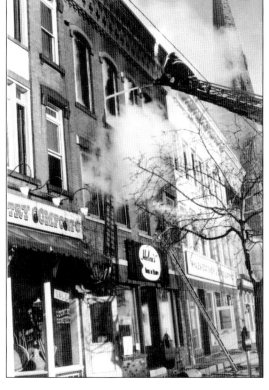

A fire broke out on February 7, 1982, in apartments at 147–151 Main Street. In this photograph, a Northampton firefighter at the top of the 1952 Seagrave ladder is working to get the blaze under control. The iconic First Church stone steeple can be seen in the background through the smoke. (Courtesy of Northampton Fire Department Archives.)

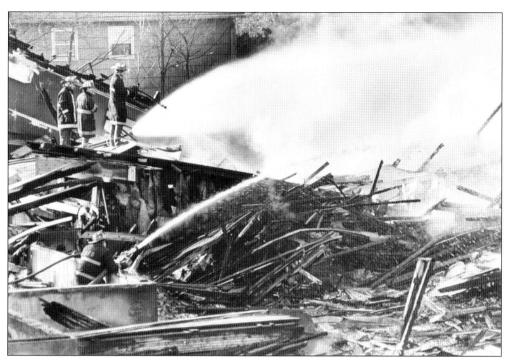

In the early morning hours of April 15, 1986, Northampton Fire Department crews responded to a fire in a 42-unit condominium that had been under construction on Randolph Place. It was about half completed at the time of the fire. The three-story wood-framed structure was a complete loss estimated at $2 million. No injuries were reported. (Courtesy of Northampton Fire Department Archives.)

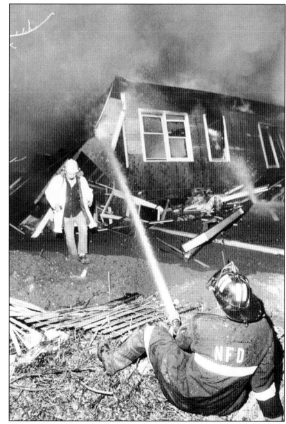

Deputy Chief Ed Passa directed Northampton Fire Department crews at the fire on Randolph Place in 1986. Northampton Fire Department was assisted by a total of 50 firefighters from four surrounding communities. Early reports indicated the cause of the fire was suspicious. (Courtesy of Northampton Fire Department Archives.)

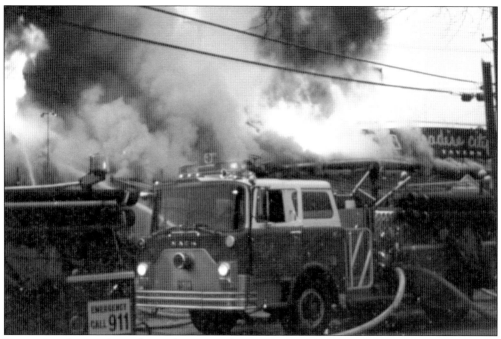

Engine No. 6, one of two identical 1988 Mack pumpers purchased in 1988, is pictured working at the Paradise City Tavern fire in February 2000. More than 60 firefighters from six communities assisted Northampton Fire Department in extinguishing the blaze. The restaurant had been open for just one year on the same lot as the iconic Original Jack August's Seafood Restaurant. (Courtesy of Northampton Fire Department Archives.)

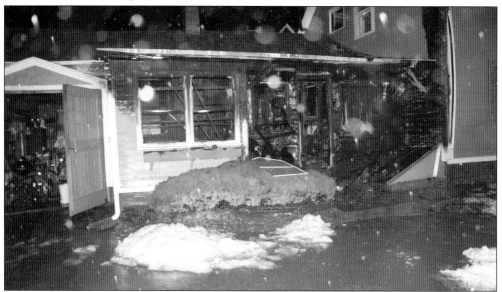

On December 27, 2009, for about an hour beginning at 2:00 a.m., a string of fires broke out in the Ward 3 area of Northampton. At least 15 fires in houses and cars had the Northampton Fire Department and surrounding firefighters rushing from scene to scene in an effort to save lives and protect property. At one of the fires on Fair Street, two people lost their lives. This was one of the many houses involved in the arson spree. (Courtesy of Northampton Fire Department Archives.)

*Five*

# Fire Alarm and Water Supply

Fire chiefs and officers would often use speaking trumpets, or bugles, to ensure their orders would be heard over the steamers and other loud noise common at a fire scene. These bugles are on display at Northampton Fire Rescue headquarters. The inscription on the one at left reads, "Presented to Lewis Warner by his friends, July 1877." The pewter trumpet at center reads, "Presented to Florence Hose Co 2, October 29th, 1879." (Courtesy of Northampton Fire Department Archives.)

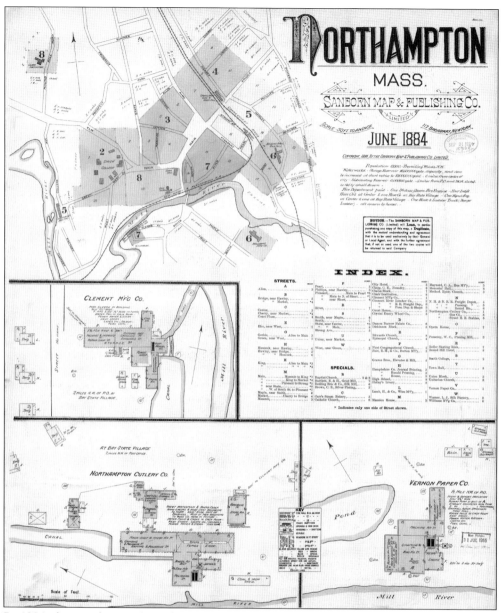

By 1884, the population of Northampton had grown to 13,500, and the municipal waterworks system had been substantially bolstered to support it. The primary reservoir was located six miles from the center of town, with a capacity of over 16 million gallons that could be expanded to 18 million at short notice. Factories and mill buildings by this point had some level of fire protection in the form of firewalls, shutters, and sliding doors. (Courtesy of Library of Congress.)

In 1889, the population was 15,000. The storage reservoir was 18 million gallons and the distributing reservoir 5 million gallons, along with 34 miles of water pipe and a total of 212 fire hydrants in town. The department was comprised of 98 men, partly paid. The fire alarm telegraph had 13 boxes and 8 miles of wire. (Courtesy of Library of Congress.)

In 1895, the population was 16,500. There were two reservoirs with a capacity of 89 million gallons and 16 million gallons, and 46.5 miles of water pipes feeding a total of 236 hydrants in Northampton and Bay State Village. Ninety-eight men were listed as volunteers, and two men were paid and always on duty. Nine men slept in the engine houses, and the Northampton Police Department provided night patrols. The fire alarm telegraph had expanded to 31 boxes in town. (Courtesy of Library of Congress.)

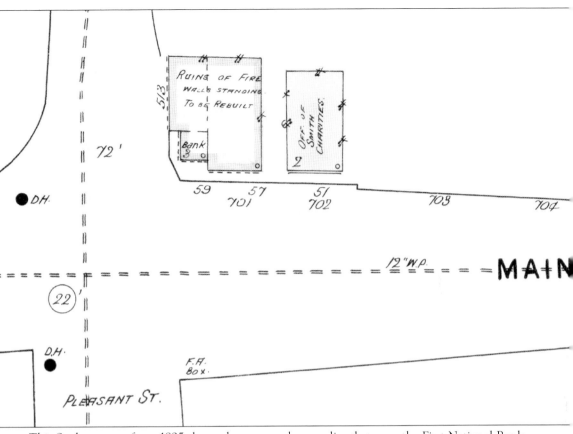

This Sanborn map from 1895 shows the corner where earlier that year, the First National Bank had been destroyed by fire, leaving just the walls standing "to be rebuilt." Sanborn maps were specifically drawn to show fire protection infrastructure. Also seen here are 12-inch water pipes (dotted lines) running down the middle of Main and Pleasant Streets, two double hydrants, and the fire alarm box on the southeast corner of the intersection. (Courtesy Library of Congress.)

In 1902, the population of Northampton had grown to 20,000. The reservoirs in Leeds (90 million gallons and 35 million gallons) were fed by streams supplying 56 miles of pipe and 300 double and triple hydrants. At the Masonic Street Station, there were 27 call men, seven paid men, and seven horses. In Florence, there were 18 call men and horses that came from a livery. The Tappan No. 1 engine had been moved here. At the Bay State Station, there were 10 call men staffing one hose wagon and a small hook and ladder truck. And in Leeds, there were 16 call men to operate a single hand engine and one hose cart. There were 50 Gamewell fire alarm boxes in town. (Courtesy of Library of Congress.)

In 1910, the population remained at 20,000, but reservoir capacity had expanded to 350 million gallons with 20-inch and 24-inch mains supply from Leeds, making a network of 66 miles of pipe. There were 348 hydrants in town at that time. This was all a major improvement since the waterworks system was established in 1871. Staffing had not changed since the 1902 assessment by the Sanborn Company, and only an additional two Gamewell fire alarm boxes had been added, for a total of 52. Streets were graded as "improved but not paved," and streetlights were electric. (Courtesy of Library of Congress.)

*Fires in Northampton* — in — December 1908

Telephone. Wednesday Dec. 2' at 12:45 Noon Olive Street near Jo. Reece (Grass)

Telephone. Sunday Dec. 6' & 1:30 P.M. Dr. Herbert Perry's 134 Elm St (Chimney)

Box 25. Thursday Dec 10' at 7:26 A.M. 7:40 A.M. in house owned & occupied by Arthur Lamountaign 56 Sumner St. Cause.
Value of building 3,800.  Value of Contents 1,600.
Ins on building 2,800.  Ins on Contents 1,800.
Loss to building 40.00  Loss on Contents 67.25

Leeds Bell. Friday Dec 11' at 7 A.M. the bell rang for a fire in house owned & occupied by Joseph Verville 124 Water St Leeds near the old reservoir out of reach of a hydrant necessitating the use of the old hand tub to which 56 men pumped heroically for two consecutive hours
Value of building 2,000.  Value of Contents 1,000.
Ins on building 1,000.  Ins on Contents 500.00
Loss to building 846.00  Loss on Contents 500.00

Telephone. Saturday Dec. 19' at 3 P.M. Mandells shoe store 161 Main Street smoke in basement no Loss — Cause —

Box 65. Saturday Dec. 19' 5.22 P.M. 5.50 P.M. Chimney (no Loss) In house owned & occupied by Mrs Wm P. Andrews Chestnut St. Florence an error was made in the hitch up and the chemical & hose combination wagon was overturned doing considerable damage to the apparatus & endangering the lives of the firemen

Telephone - Sunday Dec 20' 2.30 P.M. H. M Abbott 42 West St. Chimney no Loss

Telephone. Wednesday Dec 23' 9 A.M. Mrs Hannah Bridgman Pine St. Florence Chimney No Loss.

Telephone. Thursday Dec 24' 8:45 A.M. 164 Elm St G. D. Hazen Chimney No Loss.

Telephone - Saturday Dec 26' 3.30 P.M. J. Dorsey 29 Cherry St Wood box no Loss.
v 1,800. $14.00 $20.00

Telephone. Monday Dec 28' 10.40 P.M. Tree on Fort Hill No Loss -

Telephone. Tuesday Dec 30' 9.50 A.M. M. E. Clark 12 School St Chimney (no Loss.)

This page from the logbook in December 1908 highlights the different ways in which the fire department was notified of fires. Although at that time there were 50 Gamewell fire alarm boxes in town that connected to all four firehouses, the chief's annual report indicates that most of the calls were by telephone. The fire bells were still in operation as well. (Courtesy of Northampton Fire Department Archives.)

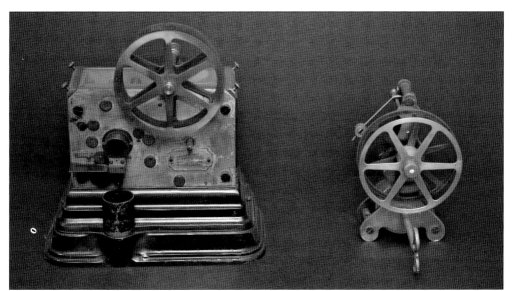

Northampton adopted the first fire alarm telegraph in 1890, headed by Charles S. Pratt Jr., superintendent of fire alarm. By 1895, the system consisted of 31 Gamewell fire alarm boxes around town. That number expanded to 50 by 1902. By 1915, there were 58 Gamewell boxes in town, and alarm bells had been installed at each station. Beginning as early as 1910, the alarm system was tested every night at 7:15 p.m. At the sound of the bells, horses would move from their stalls and have their harnesses lowered on them. The alarm system was monitored by a dedicated fireman. (Courtesy of Northampton Fire Department Archives.)

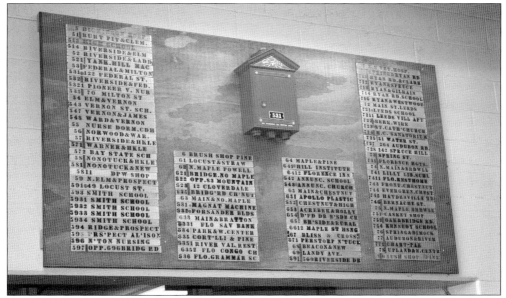

A Gamewell fire alarm box and corresponding number plates originally in the Florence Fire Station are now on display at Northampton Fire Rescue headquarters. The first digit of the number indicated which of the wards the alarm was coming from, followed by a pause to identify the box number. Only a single alarm could be sent when a box was open. The electric fire alarm was also installed in the Florence firehouse, transmitting alarms from around the village in 1883. (Courtesy of Northampton Fire Department Archives.)

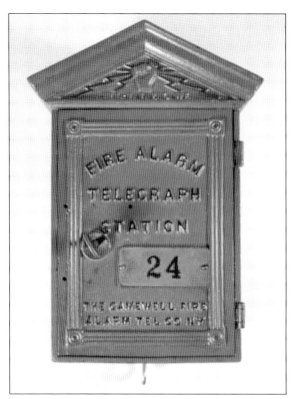

This red-painted metal fire alarm telegraph box with a key and black lettering reads, "Manufactured by the Campbell Fire Alarm Telegraph Co of New York." Brass keys were used to open the box. When the handle inside was pulled, they sent a signal to the firehouse's electric fire alarm bell, transmitting alarms from around the village. (Both, courtesy of Historic Northampton.)

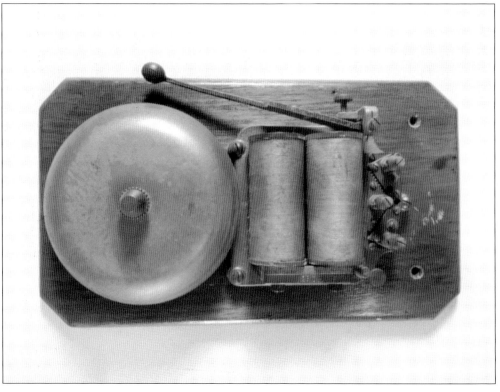

A new alarm system was added to the Masonic Street Station in 1887. All alarm boxes in the city were connected to this bell, now on display at Northampton Fire Rescue headquarters. The indicator at the top of the housing told firemen which alarm had come in, in addition to the clanging of the bell. (Courtesy of Northampton Fire Department Archives.)

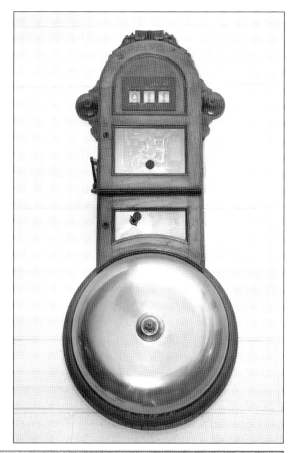

As early as the 1880s, automatic sprinklers were installed in many of the industrial buildings, along with hose carts, standpipe systems, and even dedicated watchmen responsible for patrolling the structures on evenings and weekends. This tool was used by firefighters to stop the flow of water from sprinkler heads that had opened. (Photograph by author.)

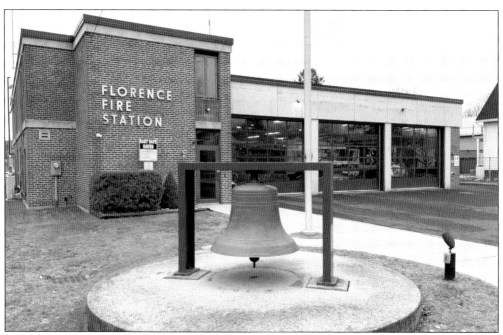

The original bell that hung in the Masonic Street Station tower was cast by William Blake & Co. in 1878 and weighed 1,700 pounds. It was moved to the Florence Fire Station in 1883 after the downtown bell was replaced. It is now on display in front of the Maple Street Station. (Photograph by author.)

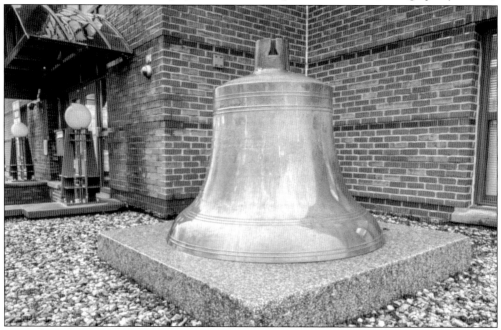

A new bell was lifted into the tower at the Masonic Street Station in October 1883. Weighing over 3,000 pounds, the bell has the following Latin phrase cast on one side: *Igne furente, populum conclamo*, which translates to "When the fire rages, I alarm the people." On the other side are the names of Chief Lewis Warner and other members of the Office of Board of Engineers. (Photograph by author.)

The 1936 annual report of the chief of the fire department was prepared by Chief J.L. Lucier. During that year, there were a total of 274 alarms. The most common cause of a fire was unclean chimneys. The same year, the Northampton Fire Department responded to six calls for cats in trees. In the same year as the Great Connecticut River Valley Flood of March 1936, there is only one comment of "rescue work during flood." (Courtesy of Northampton Fire Department Archives.)

FORTY-SECOND ANNUAL REPORT

OF THE

# Fire Department

CITY OF NORTHAMPTON, MASS.

FOR THE

**Year Ending December 31, 1936**

Beginning in the years during World War II as part of a national effort, Northampton Fire Department participated in a Hampshire County Mutual Aid network of responders who could deploy to bombed cities to lend help. A countywide radio system was tested weekly. Neighborhood wardens also served as aircraft spotters and enforced blackout regulations if deemed appropriate. This helmet is inscribed "Waldo Clark, #10, Northampton F.D. Auxiliary." (Photograph by author.)

Northampton adopted the first fire alarm telegraph in 1890 under the direction of Supt. Charles S. Pratt. By 1915, there were 58 Gamewell boxes in town, and alarm bells had been installed at each of the four stations. (Photograph by author.)

Today, Northampton Public Safety, located at Northampton Fire Rescue headquarters on Carlon Drive, is a separate dedicated 911 system providing trained dispatchers receiving calls for police, fire, and medical emergencies. In this photograph, Lisa Day takes a 911 call while sending units to the scene of an emergency in Northampton. (Photograph by author.)

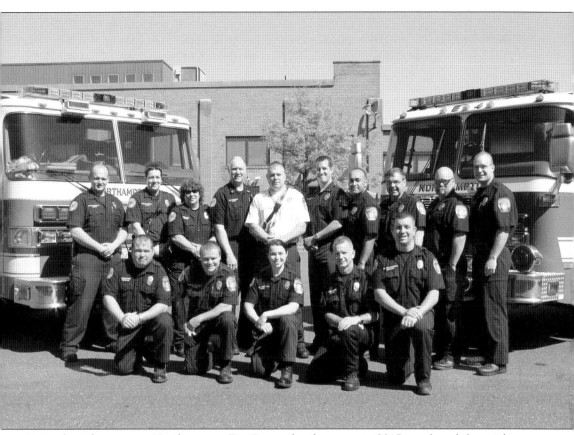

Pictured on the apron at Northampton Fire Rescue headquarters in 2015 are, from left to right, firefighter-paramedic Adam Martin, firefighter-paramedic Josh Coates, firefighter Tracy Discoll-Horton, Capt. Tom Clark, Deputy Chief Jon Davine, Capt. Bill Millin, firefighter-EMT Sam Soto, firefighter-EMT John Morriary, firefighter-paramedic Steve Hall, firefighter-paramedic Matthew Marchand, firefighter Bill Dawkins, firefighter-EMT Brett Gauger, firefighter-paramedic Kara Ledoux, firefighter-paramedic Josh Shanley, and firefighter-EMT Dennis Nazzaro. (Courtesy of Northampton Fire Department Archives.)

# DISCOVER THOUSANDS OF LOCAL HISTORY BOOKS FEATURING MILLIONS OF VINTAGE IMAGES

Arcadia Publishing, the leading local history publisher in the United States, is committed to making history accessible and meaningful through publishing books that celebrate and preserve the heritage of America's people and places.

Find more books like this at
**www.arcadiapublishing.com**

Search for your hometown history, your old stomping grounds, and even your favorite sports team.

Consistent with our mission to preserve history on a local level, this book was printed in South Carolina on American-made paper and manufactured entirely in the United States. Products carrying the accredited Forest Stewardship Council (FSC) label are printed on 100 percent FSC-certified paper.